JACKIE SHAW'S
Learn to Paint
FLOWERS

A Step-by-Step Approach
to Beautiful Results

DESIGN ORIGINALS
an Imprint of Fox Chapel Publishing
www.d-originals.com

To my husband, Lynn, who truly is "the wind beneath my wings."

ACKNOWLEDGMENTS

Part of the joy of doing a book like this is the opportunity it affords to meet new people while pursuing friends' leads. For this, we are grateful to Betty and Joe Frushour, Harold Stottlemyer, Gary Hoffman, Elsa Hoffman, and Priscilla Harsh.

A large measure of joy results from having to stretch and grow and watching as family also stretches to accommodate an increasingly frenetic schedule and mushrooming needs. This book is as much my husband Lynn's as it is mine. It would have been impossible without his help organizing and managing the computer files; finding things I misfiled (or failed to save) in that wondrous, exasperating electronic vacuum; prodding the computer back into service every time it called "time out!"; keeping track of the hundreds of photographs and illustrations; keying every image and bit of text so they would appear in the proper places in the book; and particularly for loving and appreciating me through it all. Special thanks go also to my mother, Grace Waters Bisese, and to our youngest daughter, Jen Reese, for helping with the manuscript; and to our two other daughters Kathy Graham and Laura Duvall; all three sons-in-law, Andy, John, and David; and grandchildren Savanah, Jimmy, Colton, Madison, Tommy, and Elena, for patiently enduring us while we focused single-mindedly on this book.

An enormous debt of gratitude goes to Mindie Conway who stepped in to relieve my worry and tend all my cherished gardens while I had to be content with the images from them on my computer screen.

For their generosity in providing unlimited access to their orchards, great appreciation goes to Clopper's Orchards in Smithsburg, Maryland, and to Margie and Lawrence Johnson in Valley Center, California.

For sharing and caring and patiently waiting for us to return to a normal life, special thanks to Jody and Nicholas Long and Heidi and Steve Lippman.

And of course, had it not been for all my wonderful students throughout the United States and abroad on whom I practiced and developed techniques, whose needs made me stretch, and whose sharing helped me grow, I would not have been able to do such a book. Special thanks to them all, and to the following magazines in which some of these lessons or variations first appeared: *Decorative Artist's Workbook, Tole World*, and *Quick and Easy Painting*.

ACQUISITION EDITOR: Carole Giagnocavo
DEVELOPMENTAL EDITOR: Margaret Riley
EDITOR: Katie Weeber

ISBN 978-1-57421-863-3

Library of Congress Cataloging-in-Publication Data

Names: Shaw, Jackie, author.
Title: Jackie Shaw's learn to paint flowers / Jackie Shaw.
Description: East Petersburg : New Design Originals Corporation, 2016. |
 Includes index.
Identifiers: LCCN 2015030334 | ISBN 9781574218633
Subjects: LCSH: Flowers in art. | Painting--Technique.
Classification: LCC ND1400 .S525 2016 | DDC 745.7/23--dc23
LC record available at http://lccn.loc.gov/2015030334

Every child is an artist. The problem is how
to remain an artist once he grows up.

—*Pablo Picasso*

INTRODUCTION

———

Capturing images, impressions, and emotions that stir us, and expressing them in paint, is one of life's great creative adventures. It gives us the opportunity for self-exploration, as well as creative self-expression. The creative process is an innate part of our being and allows us to indulge the "child" in us. Unfortunately, for many that innate creativity is submerged under fears and insecurities. If we worry about how our art or creativity will be perceived or judged by others, we paint with timidity and fear rather than with the free, exploring spirit we had as children.

Before we learned that we had to color neatly within the lines of the coloring book, and that dogs were not green, and walls were not for drawing on, we were all very creative. If you believe you are no longer creative, you need to know that you can be again; but you must regain your child-like daring and independence. You must be willing to experiment and to attempt the somewhat absurd at times, and to be flexible, nonconforming, and curious. You must redevelop your courage and self-confidence and, above all, be willing to risk failure in order to attain success. Before you learned to walk, you fell down a lot; but you grew stronger and more resolute in the process.

Be bold. Accept that you will paint some failures along the way, but try to learn from them. We learn more from our frustrating mistakes than from our easy successes. Be positive and expect to succeed. If you continually tell yourself, "I can't do this," you'll soon convince yourself, thus paving the way for failure. Think "I can," and you will!

CONTENTS

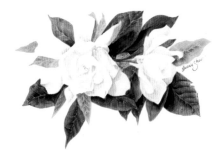

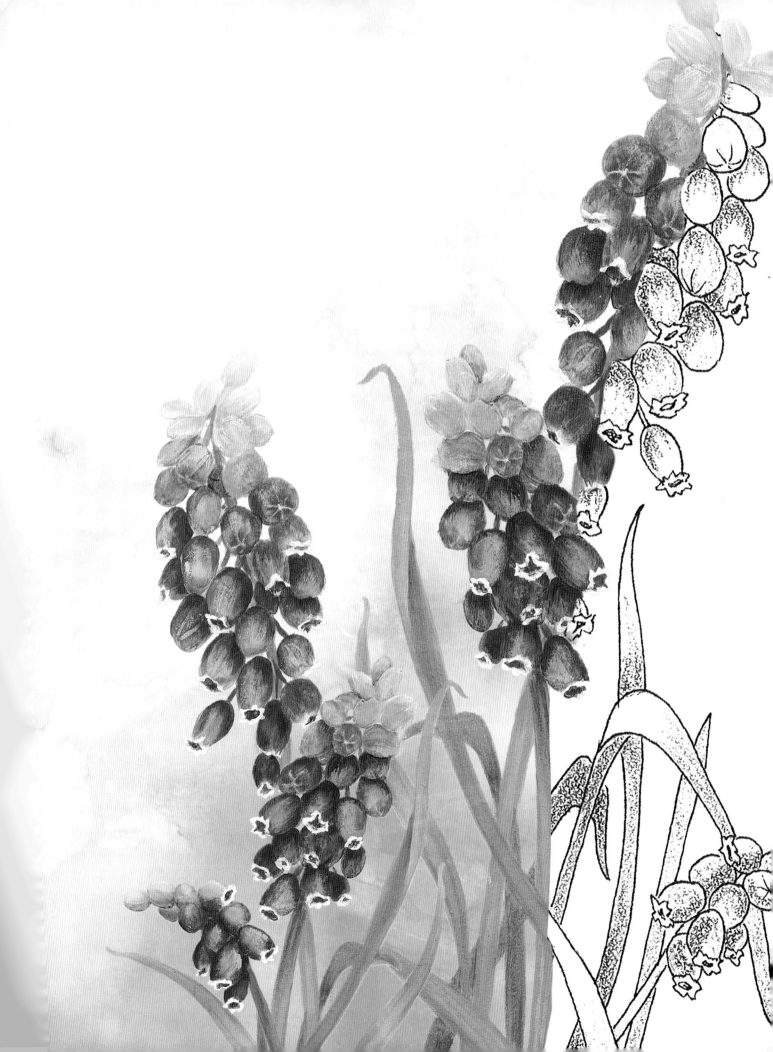

Getting Started

To get started, you'll need only a few basic brushes and paints. For the other supplies, you can "make do" with common household items to keep your initial expenses down. You don't even have to be able to draw, because I'll tell you several ways you can transfer patterns onto your surface. You may need to return to this chapter frequently in the beginning if the brush techniques discussed are new to you. So mark its location with a tab or ribbon for quick reference.

You've taken the first step on your painting adventure by picking up this book. Now let's get you started collecting supplies and learning how to use them.

Basic Supplies

You can get started on your lifetime of creative self-expression with just a small investment. Your most important tools are brushes and paints, of which there is a wide range of price and quality. Pamper yourself with the best quality you can afford. Your brushes, if well cared for, will last a long time. And quality paints (with lots of pigment) will help you achieve the results you seek, and are a joy to work with. Inferior products will undermine both your efforts and your confidence.

While it is handy to have an assortment of brush sizes, you can get by substituting the basic brushes listed below for other brushes and sizes suggested in the lessons. Mixing paints is a lot of trial and error to achieve a specific color. Don't panic—just mix and create.

PAINTS: DECOART AMERICANA ACRYLICS
Substitute your preferred paint brand and colors as desired. See page 8.
- Primary Red
- Primary Blue
- Yellow Light
- Titanium (Snow) White
- Lamp (Ebony) Black
- Purchase additional paints when you're ready, concentrating first on additional primary colors.

BRUSHES: LOEW-CORNELL SYNTHETIC TAKLON BRUSHES
Substitute your preferred brush brand and sizes as desired. See page 10.
- Flats: Nos. 2, 6, and 10 (Series 7300)
- Round: No. 2 (Series 7040)
- Liner: No. 1 (Series JS)

MISCELLANEOUS
- Paint extender medium
- Pad of 9- by 12-inch Bristol board (art paper), watercolor paper (hot pressed), or poster board to paint on
- Tracing paper for copying patterns

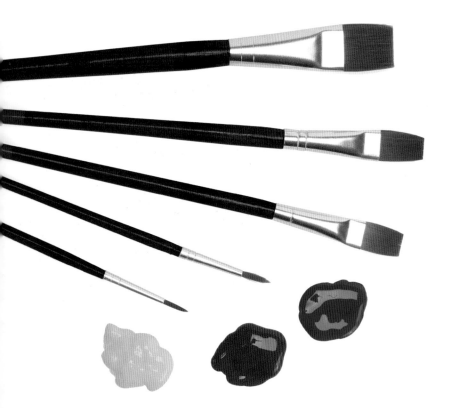

HOUSEHOLD ITEMS

- Jar of water (for rinsing brushes)
- Bottle cap or jar lid (for holding water or painting medium on the palette)
- Paper towels (for blotting brushes)
- Foam or wax-coated paper plates, foam meat tray, or freezer paper (shiny side only) for palette to squeeze paint on, to mix paint, and to blend paint on
- Plastic knife (for mixing paints)
- Pencil or chalk (for sketching and making transfer paper)
- Dead ballpoint pen (for transferring patterns)
- Soap (such as Ivory) for cleaning brushes
- Alcohol, fingernail polish remover, or acetone (for cleaning badly neglected brushes)
- Cotton swabs (for lifting out damp paint)
- Hair dryer (handy for speeding up the drying of paints)
- Old toothbrush (for spattering water onto acrylics on the palette to keep them moist)

WISH LIST ITEMS

- Flat brushes: Nos. 4, 8, and 12 (Series 7300)
- Round brushes: Nos. 0 and 4 (Series 7040)
- Liner brushes: Nos. 2 and 10/0 (Series JS)
- Dagger brush: ¼" (Series 7800)
- Round brush: No. 8 (Series Fabric Dye)
- Brush tub (for rinsing brushes)
- Plastic palette storage cups (for holding water and medium)
- Trowel-type palette knife (for mixing paints)
- Disposable paper palette (on which to squeeze and mix paints)
- Chacopaper in blue and white, plus graphite paper in black or gray.
- Stylus (for transferring patterns)
- Brush cleaner for acrylic paints (for cleaning brushes)
- Spray mister (to keep acrylics moist)
- Purchased or homemade wet palette (to keep acrylics fresh longer; see page 8)

Supplies for Special Backgrounds

There are a number of specialty and household items that can be used to achieve interesting background effects. On page 47 I explain a number of faux finish techniques, which make use of these supplies.

- 1" foam brush
- 2" sponge/foam paint roller
- Chip brush: 1" (Series 2053, for streaking)
- Flat wash brushes: ½", ¾", 1" (Series 7550)
- Sponges (synthetic or natural)
- Plastic wrap
- Plastic mesh bag
- Weathered wood finishing product
- Woodgraining comb
- Chamois cloth

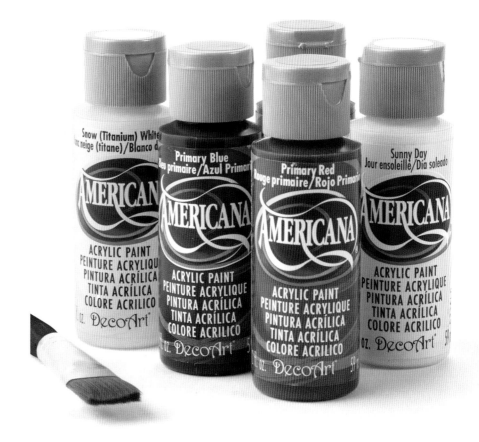

ABOUT PAINTS

The paints used throughout the step-by-step lessons in this book are acrylics in squeezable bottles. My chosen brand is DecoArt Americana Acrylics, but you can substitute any brand or colors you prefer. Do be aware that some brands have similar paint names but their colors differ greatly. Or, they may have similar colors but quite different names. You can find conversion charts from one company to another online. If you already have other paints (tube acrylics, watercolors, oils) you can use them, making adjustments to accommodate their different attributes. Tube acrylics, other than needing a little more thinning for the washes and floated colors, will work like the bottled acrylics. Watercolors, which are traditionally used by building up layers of thin washes, respond similarly to the way acrylics work in washes. The greatest difference with acrylics is the use of colored backgrounds and opaque, colored undercoats. Oil paints, because of their slow drying time, do not lend themselves as readily to the buildup of thin layers. However, this technique was inspired by the old masters and their use of glazes over light undercoats to create luminous "glowing-from-within" effects. It just took longer drying periods and the use of drying agents added to their paints. A fast-drying oil paint, Genesis, can be heat set to hasten the drying time, thus allowing it to be used much like acrylics.

Prolonging the "Open Time"

The beauty of acrylics is that they dry quickly on our paintings. The frustrating thing about acrylics is that they dry quickly on our palettes. You can delay the drying time by mixing in a painting medium (see below) or by keeping a spray mister handy to mist the puddles of paint on your palette. Otherwise, flick water onto the paint piles with a wet toothbrush. You can also keep the paints workable longer by using a wet palette—a plastic box containing a sponge to be soaked in water and special water-absorbent palette paper that wicks water up into the puddle of paint. Create a makeshift wet palette by dipping a folded paper towel in water and covering it with a piece of deli paper or butcher/freezer paper. Paints squeezed onto that paper "sandwich" will dry more slowly than those squeezed onto a regular disposable palette.

Using Painting Mediums

Painting mediums or paint extender mediums are designed to extend the "open," or "working," time of the paint, rendering it more flexible and easier to work with when using techniques that require slower drying paints, such as applying washes. Use a medium of your choice. Any one medium can be mixed with acrylic paint to prolong the drying time. The medium can be applied directly to the surface or over layers of dry paint, and paint can then be worked into it while it is still wet. Painting mediums can also be used to render the paints more translucent: The greater the proportion of medium to paint, the more translucent the paint will be. Once the paint/medium mixture starts to set up on your painting, or feels like it's beginning to drag, avoid stroking over it further. It will no longer react smoothly. To prevent reactivating paint layers that have had medium added to them, dry them thoroughly with a hair dryer before making additional paint applications. Otherwise, moisture may cause the previous paint layer to lift off. If the surface is cool to the touch, it is not dry.

Most extender mediums are approximately the thickness of bottled acrylic paint. Use them directly from the bottle or thin them with water if a finer application is desired. Mix a little into your puddle of paint, or pick some up on the edge of your brush along with a little paint and blend them together on the palette.

The heaviest painting mediums, when applied directly to the painting surface or mixed into the paints, will allow you to move the acrylic paint around much like working with oil paint. Thicker mediums give the acrylics more body and thus help hold the paint in piles, rather than thinning it down into puddles.

Creating Paint Mixtures

The lessons and worksheets are designed to make it as easy as possible to paint each subject, without having to worry about too many color mixtures, and whether or not you've mixed exactly the right color.

Note: When you know the color you're trying to create, it's best to start with the lighter or weaker color and add the darker or stronger one to it. Some colors are more intense or have more overpowering pigment than others. If you wanted to mix pink, for example, and did so by adding white to red, you might end up with enough mixture to paint a room in your house before you achieved the light pink tint you wanted. Instead, add red to white, mixing in small increments at a time.

Surfaces to Paint On

One of the joys of working with acrylic paints is the ease with which they can be used for painting on a variety of surfaces. In this book, I have focused on the painting of subject matter and have worked primarily on assorted artists' papers. A block of inexpensive watercolor paper or a pad of Bristol board will serve sufficiently for practicing the lessons, although more expensive watercolor paper will yield happier results.

Matching Paint

When mixing paints, compare them to the area to be painted using the step-by-step worksheet for comparison. Lighten or darken as needed but most importantly mix colors that are pleasing to you.

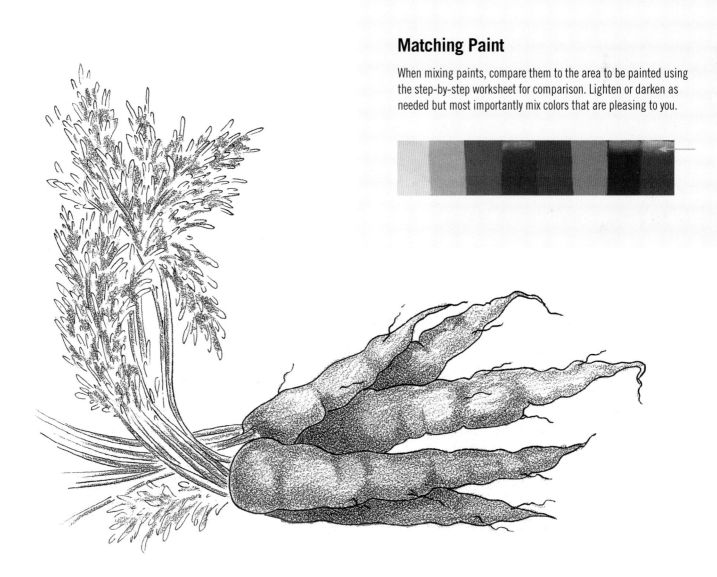

ABOUT BRUSHES

Side/corner/edge

Chisel edge

Hairs

Heel

Metal ferrule

Crimp

Handle

Take a minute to learn the names of the parts of a brush. They will be referred to throughout this book.

The Loew-Cornell series of brushes I recommend are composed of synthetic Taklon filaments, ideal for use with acrylic paints. They do not get easily waterlogged and limp as lesser quality brushes often do. In fact, they are quite resilient and snap back to their original shape after stroking with them. The flat brushes are evenly formed with sharp chisel edges, which are vital for painting careful details. Likewise, the round brushes form fine points, with no stray or uneven hairs to spoil your painted effects. The handles of the brushes are held snugly in their metal ferrules—a wobbly brush is no fun to paint with! These moderately priced brushes will serve you well if you treat them with the care they deserve. I clearly love working with these brushes, but as with any of the materials in this book, feel free to substitute the brushes listed with those of your preferred brand or size. If you are substituting brushes, look for the features described to help in your search.

Getting to Know Your Brushes

Your brushes can last a very long time, or become practically useless after your first painting session (that should get your attention!). Let's make sure yours last and remain in excellent condition, because it's difficult—to nearly impossible—to do great work with poor brushes.

Before using your brushes the first time, take a few minutes to familiarize yourself with them in their new condition. It will make it easier for you to keep them like new. First, remove the factory applied sizing that stiffens the hairs and protects them in shipment. Dip the hairs in water and squeeze them gently between your thumb and forefinger to loosen the sizing. Rinse the brush well, then dry it by stroking it on both sides on a soft cloth or paper towel. Notice how the bottom edge of the hairs forms a sharp, chisel edge. The hairs lie straight and tight together and have no outward curl. This tight grouping of the hairs makes managing paint easy. Curly hairs cause problems. A good quality, new brush should be resilient, with hairs that snap back quickly to their original shape after use, and no stray hairs. A waterlogged brush, or an inferior quality brush will have limp, unresponsive, uneven hairs.

Next, notice the smooth transition from the metal ferrule to the hairs. Slide your thumb and forefinger along the ferrule and off onto the hairs. Do this several times. Memorize the smooth feel of the transition. You don't notice any lumpy formation at the junction of the ferrule and the hairs. If paint is not meticulously cleaned from your brushes each time you use them, and even *while* you're using them, it will dry in the hairs at the base of the ferrule. Over time, a thick, hard knot will form, causing the hairs to splay out and open a sort of tunnel when looked at from the hair end of the brush. The hairs may also separate like teeth on a comb.

With splayed hairs, it is impossible to get a sharp chisel edge on the brush, making it hard to control where the paint is going to go.

The handle of your new brush fits snugly in its ferrule, held in place by the crimp; and with its highly lacquered finish it is a pleasure to hold. A brush left standing in water, which covers the ferrule and part of the wood handle, will soon loosen, a result of subsequent soaking and drying out. It's hard to control a wobbly handled brush. The swelling and shrinking of the wood will also cause the lacquer to crack and peel, making an unpleasant feeling handle. Left standing too long in water, the hairs of the brush will bend. And as unlikely as it sounds, acrylic paint will harden in the hairs even though they're submerged.

That's the bad news. The good news is you can prevent the premature demise of your brushes with attentive care.

Cleaning Your Brushes

Clean your brushes thoroughly at the end of each painting session. If you're working long or hard with the brushes, take a break and give them a good cleaning during the session. Don't leave them standing or dangling in water. They will become water logged and limp, and the acrylic paints will begin to set, even in the wet hairs. If you know your brushes are expensive, all the more reason to keep them cleaned.

1. Rinse out as much paint as possible, then stroke the hairs of the brush on a wet bar of soap, taking as much soap into them as possible. Or dip them in brush cleaner for acrylic paints. Do not scrub the hairs into the bar of soap or in the palm of your hand to load them with soap or cleaner. The scrubbing motion weakens and wears the hairs, causing them to break and curl.

2. With soap in the brush hairs, pinch the hairs between your thumb and forefinger, squeezing the soap up toward the ferrule. Wiggle the brush gently to work the soap amongst the hairs. Do not bend the hairs sharply against the ferrule.

3. Rinse well, then repeat steps 1 and 2 until every trace of color is gone. If any color remains to tint the soap, that means there is still paint in your brush. Tiny amounts left behind after each cleaning soon mount up to a big knot. So keep working.

4. When you're convinced no paint remains in the brush, rinse it well, then stroke it on the clean bar of soap once more. Leaving the soap in the brush, shape the hairs as they were when you first bought the brush: flat brushes to a smooth chisel edge; round brushes and liner brushes to a fine point.

5. Lay the brushes flat to dry. (If you stand them on their ends in a container before they are completely dry, some of the moisture that remains in the hairs and ferrule can drain down to the wood handle.) Place on a paper towel to dry. If you instantly see a tint of color on the paper towel, clean your brush again. Be sure your bristles are not leaning against another brush or your bristles will not dry into their original shape. Once they are dry, it's safe to store them in a jar (hairs up) or in a box or other container. The soap in the hairs will dry stiff to protect them and help them retain their like-new shape. Before using the brushes again, simply rinse them well.

(Whoops!) Repairing the Damage

What do you do if you accidently let paint dry in a brush or store it upside down? Accidents do happen. Distractions undermine our best intentions, and a paint-filled brush gets set aside and forgotten. Even though the paint has dried and the hairs are stiff as peanut brittle, don't throw the brush away.

Removing Hardened Paint

Soak the hairs in alcohol, acetone, or nail polish remover containing acetone. Remember to do this in a well-ventilated room. Take precautions to keep the fluid off the handle or it will dissolve the lacquer into a sticky mess.

Two ways to soak a damaged brush.

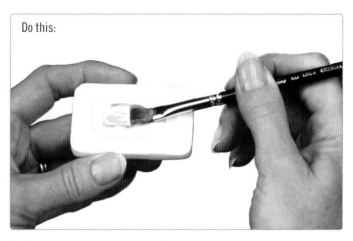

Do this:

Stroke your brush gently to load with soap.

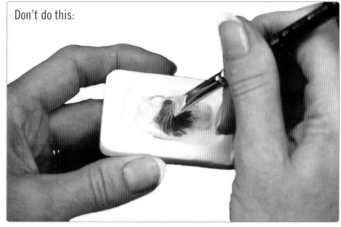

Don't do this:

Do not scrub the hairs in a circular motion!

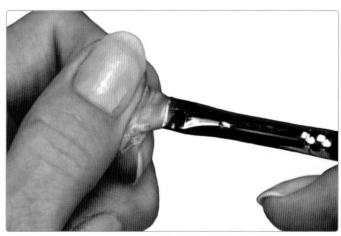

Squeeze the soap gently up toward the ferrule.

A jar lid or a saucer with a rim makes a good soaking dish. You can use a clothespin or two to elevate the brush at an angle into a saucer or lid. Stand the clothespin on its two "legs," letting the brush be the third "leg" of a tripod. Just be sure that the weight of the brush does not bend the hairs. Or, suspend the brush in a jar, so the hairs do not rest on the bottom, by using spring type clothespins to hold the handle. Cover the container with foil or plastic wrap if you can do so without including the brush handle. Concentrated fumes can also soften the lacquer.

After the dried paint has loosened, clean the brush as described before. The solvent soak is a harsh measure, so don't use it as a part of your regular cleaning routine. And as harsh as it is, it will not undo the tunnel or the split-comb type damage caused by paint drying in the hairs, near the ferrule.

Straightening Curved Hairs

If you left a brush standing on its hairs in water, or cramped it in storage so that the hairs are now permanently curved in one direction, there is an easy remedy. Dip the hairs (not the ferrule) quickly in and out of very hot water. (The brush hairs are held in the ferrule with glue that could loosen in hot water, resulting in a hairless brush.) Repeat as necessary until the hairs are straight. Then stroke the brush on a damp bar of soap and shape the hairs. This hot-water dip will not straighten fuzzy, every-which-way curls that result from misuse, rough surfaces, and scrubbing.

Which Brush Should You Use?

Ideal brush sizes are suggested for each lesson. If you have not accumulated a range of sizes yet, substitute the largest brushes you can comfortably handle for the ones suggested. If you enlarge or reduce the patterns, then the "ideal" brush sizes would need to be adjusted to correspond. Just remember, though, that the magic is not in a given brush size but rather in your technique.

Brush Size

If you are using a different brand, there may be some variation between my brush sizes and yours. For example, your size No. 6 may not be the same size as my No. 6. So use my recommendations only as a suggestion, and be guided more by what feels comfortable to you. Just be aware that in the beginning, you will probably choose a slightly smaller brush size than would be most expedient. Try to always use the largest brush you can comfortably handle in any given area. It's more efficient, and you're less likely to fidget your painting to death the way you might using a too-small brush. This is true, also, if you're starting with just the three flat brushes listed as basic supplies. Use a brush size suitable to the size of area you are to paint. You wouldn't use a liner brush to paint a 4" area. Sizes of brushes range in number size with generally the smallest to the largest numerically (i.e., No. 12 flat is larger than a No. 2 flat).

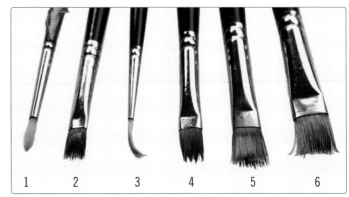

When your brushes look like this, here's what you're doing wrong: (1) Handles split, peel, and wobble when they're allowed to soak in water. (2) Acrylic paint will harden in a brush that is not properly cleaned. (3) Hairs bend in storage or when carelessly left standing in water. (4) Comb-like separation of hairs is caused by dried paint. (5) Tunneling effect is caused by paint hardening near the ferrule. (6) Curling hairs result from rough treatment and rough surfaces.

Brush Style

As a general rule, you will use flat brushes to undercoat, to apply washes and sideloaded and doubleloaded strokes, to highlight and shade, and, sometimes, to apply drybrushed effects. Use the liner and round brushes to paint thin lines and small details. Sometimes I will suggest you use a flat brush for some details (such as veins of leaves) just to keep them from looking too stiff and artificial. Highlights painted with the corner of the flat brush look softer and more natural than the precise, hard little dots applied with the liner brush. Narrow, straight lines can also be painted with the chisel edge of the flat brush when it is held perpendicular to the painting surface. Such lines are softer and less defined than those made with the liner brush. Use the round brushes for painting particular strokes, such as for forming seeds, flower petals, and textured citrus flesh. Use an old, splayed brush (flat or round) with hairs sticking in all directions—we'll call it a "scruffy" or "ratty" brush—to apply drybrushed effects and techniques like stippling, pouncing, and others as instructed.

To Trash or Not to Trash?

Damaged brushes are still usable, but not for careful blending techniques and precise strokes. They are handy tools for creating special effects. Instead of using a good brush for drybrushing, scumbling, pouncing, spackling, streaking, or dabbing, grab one of these scruffy or ratty brushes. They're also handy when small children and grandchildren want to paint with you. You can enjoy the painting session without worrying about the damage being done to your good brushes.

Brush-Loading Techniques

This section explains four methods of loading paint into your brush: full loading, sideloading, doubleloading, and drybrushing. Each technique yields different effects, so it is important to be familiar with all four. Because sideloading is the loading technique that stumps the greatest number of students, I have included especially detailed instructions. Don't be intimidated though; once you have mastered the technique, you can accomplish the loading quickly and efficiently, without having to think about it.

Full Loading

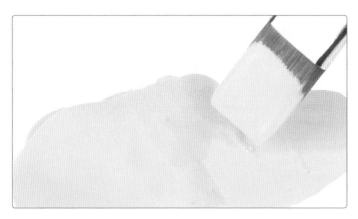

Fully loading the brush.

A fully loaded brush is a brush loaded almost to the metal ferrule with paint generally the thickness it comes from the container. To load the brush, stroke it at the edge of a puddle of paint, working the paint well up into the hairs. Merely dipping the brush in the paint and letting paint cling to the outermost hairs is not fully loading the brush. We will use a fully loaded brush primarily for opaque or textured undercoats.

Sideloading

Sideloading the brush.

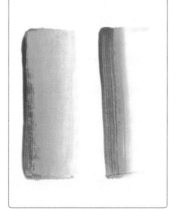

A sideloaded stroke should show a gradual (left), not abrupt (right), change in color.

A sideloaded brush is loaded along one edge with color that gradually fades to little or no color on the other edge. We'll call the edges the "paint edge" and the "water edge," respectively. A sideloaded brush produces strokes of shaded color. Such strokes facilitate the application of thin layers of paint for creating highlights, shadows, and delicate accents of color (such as tinges of red, orange, yellow, blue, and purple on leaves). By loading the brush so the water edge stays fairly free of pigment, we can use that edge to nudge or soften the sideloaded application if necessary, or to smooth a too-obvious edge of paint.

One of the most common mistakes in sideloading is not working enough paint up into the hairs of the brush. A few jabs at the paint puddle and a couple of blending strokes on the palette do not properly and sufficiently fill the brush and distribute the paint. A stroke applied with an inadequately prepared brush will have an area of thick paint laying abruptly next to a swath of water, which will quickly evaporate, leaving a hard-edged stripe of paint where you were hoping for a gradual blending of tone. A well-loaded brush, on the other hand, will produce several, nicely gradated strokes with just an occasional remoistening with water or painting medium. On your first read-through of the directions, have a flat brush, palette, paper towel, and water handy. Go through the motions as you read, substituting just water for paint. This will help embed the process in your mind before you get down to working with the paint.

1. While it is possible to sideload a variety of brush styles, develop your skill by practicing with a flat brush in excellent condition. At first, work with a No. 8, 10, or 12 brush. As your skill develops, try the smaller flat brushes.
2. Dip the brush in clean water. (If you're using oil paints, dip the brush in painting medium.) Shake off the excess; then blot the entire length of hairs, on one side only, on a paper towel. Watch the hairs, and as the wet shine disappears, immediately lift the brush. Do not blot the other side. The water or medium remaining in the brush should provide the right amount of moisture for dispersing the paint. Too much water or medium will make the paint too juicy to control; too little will cause the brush to drag and skip.

3. Pick up a little paint on the corner of the slightly damp brush.

4. Stroke the brush back and forth on the palette in a short space (no longer than an inch; even shorter for smaller brushes). Stroke over and over in the same spot, picking up more paint as needed to completely load the hairs on one side of the brush. Moving to a different clean spot on the palette with every stroke (a common mistake) will use up the paint rather than force it to load well up into the hairs of the brush.

5. Continue to add more paint, a little at a time, until color is worked almost up to the metal ferrule. Avoid loading too much paint at once since doing so will make your blending area messy. It may also make the paint spread too far across the brush, eliminating the clear water edge. Too much paint loaded at once can also force paint into the ferrule area, making brush cleaning a hassle.

6. As you stroke the brush on the palette, stroke on both the top and underside of the hairs. If you stroke only the bottom side, you will be pushing the paint up toward the top side of the hairs and it will not be worked properly into the hairs. When you flip the brush to stroke the top side, be sure to align the color edge of the brush with the color stroke on the palette.

7. When you think you have loaded sufficient paint in the brush and have blended it so it progresses from a deep color on the paint edge to a pale color or no color on the water edge, make a short test stroke on a clean spot on your palette. The stroke should show a gradual change in color.

8. If the color in your stroke changes abruptly, you need to blend on the palette a little more to distribute the paint gradually across the hairs. Try this: "Walk" the brush gradually away from the edge of the paint. If the paint is on the left edge of the brush, walk toward the right by making short strokes parallel to the original stroke, like a series of stripes. Then walk back toward the left, applying pressure on the brush while stroking, gobbling up the trail of stripes. At first, walk only half the width of the hairs of the brush until you are proficient at picking up—on the way back—all the paint deposited while walking away. Walk on both sides of the brush.

9. Another way to soften the abrupt color change in the brush, whether side- or doubleloaded (see below), is to stroke the brush on the palette, moving like a downhill slalom racer in slow motion. Stroke back and forth in this wiggly fashion several times. Then, on the same spot, finish with several straight strokes, stroking on both the top and underside of the hairs. The wiggle will help move the concentrated paint on the edge of the brush across the hairs.

10. If the paint drags a little, at any time, dip the water edge of the brush into a drop of water or medium and blot the excess. (I like to keep a large drop on my palette so it's easier to see and control how much moisture my brush picks up.) You can also use a bottle cap or a palette cup. Blend on the previous stroking area on the palette to distribute the moisture across the brush hairs.

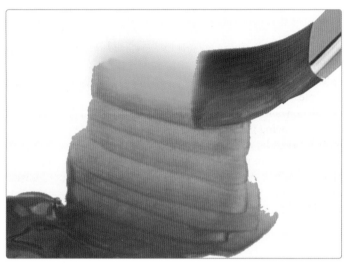

"Walking" the brush away from the paint puddle.

Whoops!

If you accidently get strong color (or in the case of doubleloading, the wrong color) across the entire brush at any time, you need not rinse the brush entirely and start over. Just dip the edge of the brush that was supposed to remain clear into a droplet of water or medium, wipe the paint off by pulling that edge through a paper towel held between your thumb and forefinger. Then pick up a little more moisture, blot it, and continue stroking and loading the brush.

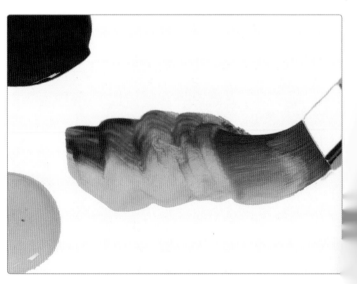

Stroking the brush in a "slalom" motion.

Doubleloading

A doubleloaded brush is loaded with two different colors or values, one on each edge. After blending the doubleloaded colors on the palette, the brush produces a stroke having three colors or values—two from the two colors loaded onto the edges of the brush and the third as a result of the two colors mixing together in the middle of the brush. The gradation of color in a doubleloaded brush makes possible the application of subtle color transitions such as in painting highlights, reflected lights, and shadow areas. The effect is slightly different from using a sideloaded brush: The color application will be more opaque, and can appear too heavy and flat if not applied thinly over previous thin-layered areas.

To doubleload the flat brush, follow the procedure for sideloading the brush, except in step 3, pick up a different color on each corner of the brush. In the test stroke you make in step 7, you should see the color from one edge of the brush gradate gradually into the color on the other edge. For example, if you loaded yellow on one edge and blue on the other, the colors should merge into green across the center of the brush. If there is an empty space in the middle or a sharp edge where one color abuts another, you haven't blended the colors sufficiently in the brush. Go on to step 8 and/or step 9, being careful not to "walk" or "zig" the brush so far as to let the yellow edge, for example, walk or zig into the blue paint, and vice versa. You will be able to walk only short distances before retracing your steps; the object being to keep the colors on the edges of the brush as pure as possible, while merging the colors in the middle.

If you need to remoisten the brush as in step 10, you can pick up water or medium sparsely on either edge. Just be sure to blot the brush before stroking on the palette to continue to blend, or the paint will puddle and you'll lose the distinct colors on the edges.

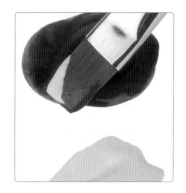

Doubleloaded brush before blending.

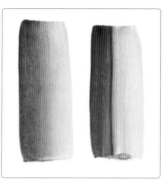

A doubleloaded brush stroke should show a gradual (left), not abrupt (right), change in color where in the two colors meet.

Whoops!

If you do lose one color, for example the yellow, it's not necessary to rinse the brush and start over completely. Moisten a small section of a paper towel, and holding it between your thumb and forefinger, pull the yellow paint edge of the brush through. Wipe off the "tainted" yellow leaving the green and blue intact. Then reload the yellow (and blue if neccessary) and proceed with the blending.

Palette-knife blending.

Brush blending.

Brush Blending on the Palette

Palette knife blending, in which two or more colors are mixed together using a palette knife, is perhaps the most familiar way of mixing different color paints. You can also mix colors by picking up on the brush a little of each color desired in the mixture and stroking—but not stirring—them together on the palette. If we avoid overmixing the colors, thereby creating one bland tone, we will have lively mixed colors that retain traces of the original hues. (Palette knife mixing can also yield the same results if not overdone.) In using such a mixture, we would most often work with a fully loaded brush.

BASIC BRUSHSTROKES

Here are seven basic brushstrokes that will help you complete the worksheets in this book. Practice each one on scrap paper until you get the hang of it before taking it to your composition.

Knife of Chisel (flat brush)
Skim the knife or chisel edge of the brush along the surface to form a thin line. Be sure to keep the brush perpendicular for the best control and narrowest line.

Broad (flat brush)
Maintaining even pressure, pull a stroke using the full width of the flat brush. Pull the brush back to a chisel edge, standing it up perpendicular to the painting surface, leaving a clean, even edge.

Comma (round brush)

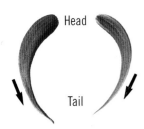

Head

Tail

1

2

3

While loading the brush, flatten the tip of the hairs and scoop up a little extra paint. For a streaky comma stroke, load the brush with one color, then tap the excess off the tip; do not wipe it off. Dip the brush in a second color, then tap it slightly to merge the colors.

Lean the brush handle slightly back in your hand. Press the brush down, letting the hairs flair out to form the rounded head.

Pull the stroke, gradually releasing pressure on the brush and letting the hairs return to a point.

Pull the stroke to a fine point, standing the brush perpendicular to the painting surface. Stop, then lift off.

Flat Comma (flat brush)

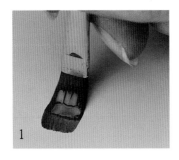

1

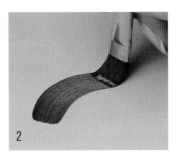

2

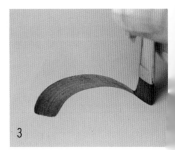

3

This stroke is created from head to tail. The brush starts at 12 o'clock. It should rotate gradually to about 2 o'clock; then stop rotating as you slide the complete stroke, pulling the tail toward 7 or 8 o'clock.

Press the brush down and begin pulling a flat stroke.

Continue pulling while releasing pressure and curving the stroke slightly. Let the handle lean into the curve.

Continue releasing pressure and pulling until the brush comes to the chisel edge. Stop and lift off.

Teardrop (round brush)

Tail

Head

This stroke is the reverse of the comma stroke: It begins skinny and ends fat. For a two-toned teardrop, load the brush with one color, then wipe the tip. Load the tip with a second color. Paint the teardrop. The last color loaded on the brush will form the teardrop's tail, the first will be found in its head.

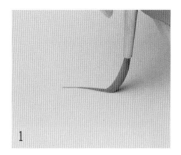

1

Begin on the tip of the brush, skimming lightly on the surface to form the tail. For best results in starting a skinny tail, begin the stroke in the air and glide gently onto the surface.

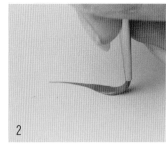

2

Gradually apply pressure while pulling the brush until you've obtained the length or fullness desired.

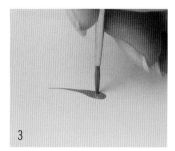

3

Come to a complete stop, then stand the brush back up on its tip perpendicular to the surface. Notice that, upon stopping, the tip of the brush is in the middle of the head. Lift off.

Flat S (flat brush)

This stroke is formed by applying and releasing pressure. Your brush should never change direction. Do not rotate it in your fingers or attempt to draw the letter S.

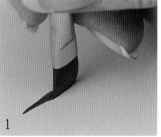

1

Start at 8 o'clock and slide toward 2 o'clock, gradually increasing pressure.

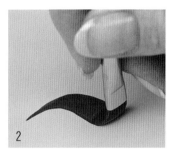

2

Continue to increase pressure as you change direction and head for 5 o'clock. In the middle of the stroke, begin gradually releasing pressure.

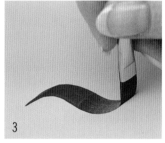

3

Continue releasing pressure as you change direction again and head for 2 o'clock, ending on the knife edge of the brush. The legs of the stroke should be parallel and the same length.

Flat Crescent (flat brush)

This stroke requires you to slide and rotate your brush to achieve the thin to thick to thin appearance.

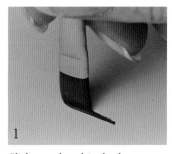

1

Slide on the chisel edge, moving the brush from 6 o'clock straight toward 9 o'clock, and gradually begin applying pressure.

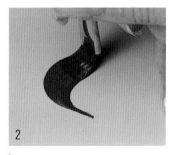

2

Increase pressure as you round the curve, rotating the brush until you are stroking with the bristles flat. Then gradually begin releasing pressure.

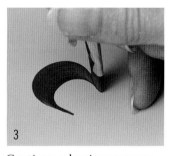

3

Continue releasing pressure and pull the brush to the chisel edge. The beginning and ending legs of the stroke should be identical—the same length and width.

SPECIAL BRUSH TECHNIQUES

Once you are familiar with the different methods of brush-loading, you can use them to create a variety of wonderful effects.

Washes and Floated Colors

A wash (also called a glaze) or floated color is a layer of thin paint usually applied with a flat brush over a dry background or undercoat. You will often see the terms used interchangeably as, indeed, the results are very similar. The paint, thinned with water or water plus a medium is translucent or semi-translucent, thus allowing some of the color of the background or undercoat to shine through. This creates a "glowing-from-within" effect if applied over a light color. When applying a wash (glaze) or floated color, be sure to put it down thinly. Dry it completely with a hair dryer before applying another layer. This will prevent the lifting or dissolving of the previous application. You can build layer upon dry layer until you build up the depth or variety of colors you want.

There are two kinds of washes or glazes: flat and gradated. A *flat wash* creates a thin but uniform color throughout. It is created by fully loading a flat brush with thinned paint. A *gradated wash* is one that progresses from strong to faded color. It is applied by sideloading a flat brush.

Floated color is the application of color over a thin layer of water or water plus medium, which has been applied over a dry undercoat or a base coat. Thus, the color is "floated" across the surface on that layer of moisture. The effect can be flat or gradated. When we work with a sideloaded brush, we are actually floating color across the moisture that the water side of the brush lays down with every stroke made. In this book, I make abundant use of washes and floated colors to build up multiple layers of thin paint; to apply shading and highlighting and accent colors; and to adjust colors or submerge them slightly when needed. I use a sideloaded brush for most of these effects, so be sure to master that brush-loading technique. The results are well worth the effort.

Puddly Wash

The "puddly" wash is, like above, the application of a thin layer of paint over a dry undercoat or background. The exception is that it is applied very juicily. It will take a while longer to dry because there will be little puddles throughout the wash, rather than a smooth, thin layer of colored moisture. The paint pigment collects in varying amounts in the puddles. When the puddles dry, the effect is a splotchy application of thin paint. Wonderful for creating spontaneous-looking, natural effects!

Flat wash.

Gradated wash.

Puddly wash.

Drybrushing

A dry brush is a brush having no moisture added before picking up very little paint, which is then mostly wiped off. A drybrushed stroke produces glittering or scattered touches of colors or highlights, which cling primarily to elevated portions of strokes painted previously.

Any brush can be used for drybrushing; but this is a great way to use your old, scruffy brushes—those that have separated, splayed, and curled, and that have paint dried in the hairs near the ferrule.

1. To load the brush, dip the tip of the dry hairs in a smear of paint on the palette. Work the paint into the hairs by stroking or rubbing the brush on the palette. (This technique can be rough on good brushes, which is why I like to use old, ratty ones!)
2. Then wipe the brush nearly dry on a dry paper towel.
3. Hold the brush parallel to your painting surface and skim lightly across the area you wish to highlight or add broken color to. If you wiped the brush sufficiently dry, you should not see any paint appear on the surface with your first stroke. It should require several passes, and even then the paint should be barely visible. As you become confident that there is barely any paint in the brush, apply more pressure as you stroke. You should have to work at laying down any color. The harder you work, in fact, the more control you have. To avoid being surprised by a too heavy application, lightly pass the brush over some dried paint on your palette to test the amount of paint in the brush.

Experimenting

Don't be afraid to experiment with different brushes and techniques than those I recommend in the lessons. In working through the lessons, you will see that, in painting leaf veins, for example, I have suggested a variety of approaches:

· Using the liner brush.
· Using a sideloaded flat brush.
· Using overlapping, sideloaded strokes to soften the previously painted stroke.
 Painting V-shaped marks to indicate veins.
 Using the chisel edge of the flat brush.
 Using a combination of techniques and brushes.

Try all the variations, then determine the brush and technique that works best for you. My goal is to assure you that there is no one "right" way of doing things. There are many ways to achieve the effects we seek. Have fun testing them all!

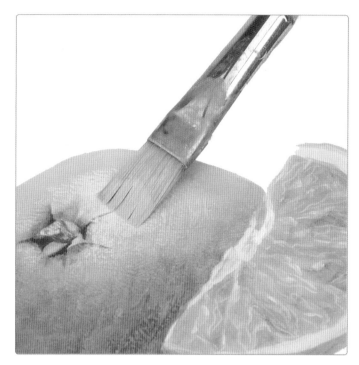

Applying drybrushed highlights.

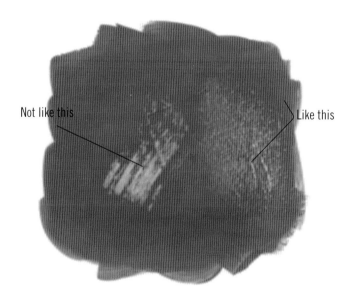

Not like this Like this

If you didn't load the paint sparsely enough, you might lay down an obvious brush stroke rather than barely perceptible glints. Quickly wipe up the paint with a damp towel and dry the area thoroughly; reload the brush and try again. Remember that it's better to apply several inadequate coats, building up to the final desired effect than to apply one, heavy, layer.

Scumbling

To scumble paint into an area is to apply it randomly in broken, overlapping patches, somewhat like crosshatching. Scumbling is a convenient way of unifying subject colors in a composition by introducing them into the background or into other areas. I usually like to soften the edges of my scumbled strokes so they don't draw too much attention to themselves. If the scumbling is done wet into wet paint, the edges of brush strokes soften readily. If the scumbling is done wet onto dry paint, it may be necessary to overstroke with a little of the original background color, thinned, to soften brush stroke edges. Scumbling can be done with a fully loaded, a sideloaded, a doubleloaded, or a (nearly) dry brush, depending upon the color(s) being used, how much of it is wanted, and the effect desired.

Lifting Out Highlights

After applying a wash or floated color, you can lift out some of the still damp color to expose more of the light undercoat. Use a damp cotton swab or clean damp brush. This must be done quickly, before the layer starts to set up, so have your brush or cotton swab already dampened (not dripping) with clean water.

Edge-to-Edge Blending

To add highlighting, shading, or accent colors in the middle of an area and to avoid having a hard edge of color, use edge-to-edge blending. This can be done with either a sideloaded or doubleloaded brush.

To blend edge-to-edge with a sideloaded brush, first slightly dampen the area to be highlighted with a painting medium plus water. Place the paint edge of the brush to the center of the area to be highlighted and blend it outward, leading with the water edge. Then quickly return to the starting point, reverse the brush, again placing the paint edge to the center of the highlight area; and this time blend in the other direction, leading with the water edge.

To blend edge to edge with a doubleloaded brush, follow the process above, omitting the layer of moisture. I generally use the doubleloaded brush if I wish to highlight or shade something that is painted opaquely. However, for working on subjects built up with thin washes and floated colors, I prefer the transparency of a sideloaded brush.

Scumbling.

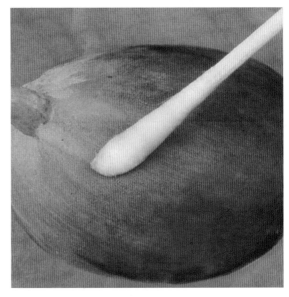

Using a cotton swab to lift out highlights.

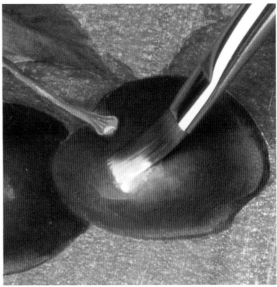

Edge-to-edge blending with sideloaded brush.

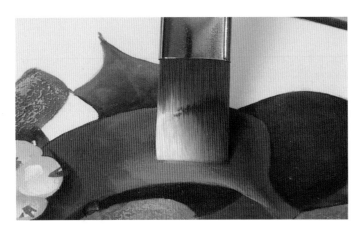

Edge-to-edge blending with doubleloaded brush.

TRANSFERRING PATTERNS

Each step-by-step lesson includes one or more patterns for you to paint from. To transfer a design onto your painting surface, first copy it onto tracing paper. (I like to use a thin, felt tip marker such as a Sanford Ultra Fine Point Sharpie or a Pigma Micron.) Then use one of the methods described below to transfer the design. Try them all, and use the one that best suits your needs at a given time.

Retracing Pattern Lines

Turn your traced design over, and on the back side retrace your pattern lines using a chalk pencil or a regular graphite pencil. Position the twice-traced pattern, chalk- or pencil-side down, on your surface. Retrace lightly over the felt tip drawn lines using a stylus or a "dead" ballpoint pen. Avoid heavy pressure. You want to transfer just a faint line of chalk or graphite from the back of the pattern, not dig a ditch in your painting surface.

Chalk or Pencil Rubbing

Turn your traced design over and rub the back side of the pattern area with the side of a piece of cheap chalkboard chalk or the graphite from a No. 2 (or softer) pencil, held almost parallel to the paper. Shake off excess chalk or graphite. Lay the coated side face down on your surface and retrace gently over your pattern lines to transfer the design. Be careful not to rub your hand over the design as the pressure will transfer smudges of chalk or graphite to your surface.

Commercial Transfer Papers

Purchase a package of artists' transfer paper, such as Chacopaper. These papers are designed specifically for use with artists' materials. Do not use regular office carbon paper as it will bleed through your paints and spoil your painting. Artists' transfer papers are available in gray, white, blue, red, and blue-green, depending on the manufacturer and available in the Fine Arts section in an art, craft, or hobby store. Position the transfer paper between your pattern and your painting surface, making sure the coated side is face down on the painting surface.

When new, the coating on the purchased transfer papers (as well as on the homemade ones described below) is heavy and will transfer a line that is much too thick, so use a light touch in working with them. I like to wipe over the coated side of commercial transfer papers with a paper towel before using them the first time to remove excess coating.

Make Your Own Transfer Paper

Rub the back of a sheet of thin tracing paper with the side of a piece of chalk or with a No. 2 (or softer) pencil, held almost parallel to the paper. Cover your fingertips with a piece of chamois cloth or paper towel and rub the chalk or graphite into the paper. Shake off excess chalk or graphite dust. Fold the coated paper in half, treated side in, for storage.

Whoops!

Avoid frustration! Pay close attention when positioning the transfer paper beneath your pattern and on your painting surface in preparation for transferring your design. It's too easy to place the transfer paper upside down; and if you don't make a habit of checking your progress after copying the first line or two, you might discover after a long, tedious tracing session that you've transferred the entire pattern onto the back of your original pattern. It is helpful to write on the transfer paper in felt tip marker, "This side up!" Or write your name, or draw a smiley face. Do something to remind yourself to be alert.

THE COLOR WHEEL

The color wheel is a wonderful and convenient way to study colors; to see how they are related to one another; and to see how they can be mixed from—and with—one another.

Seeing the colors arranged around a wheel also makes it easier to imagine, to study, and to create color schemes.

How the Color Wheel Works

For now, let's take a look at how a color wheel is created. The artist's (or pigment) color wheel is based on three primary colors—red, blue, and yellow—which are the basis for creating all other colors. We cannot create our three pure primary colors by mixing together any of our other pigments; we have to buy the primaries. But from those three purchased colors we can mix a wide range of hues. You can see eighteen of those hues on the intermediary color wheel on the following page. If we created gradual gradations between all of the colors on this wheel as well as on the tertiary color wheel, and then created nine additional values by adding black and white to every mixture on the wheel creating shades and tints; and then mixed nine more values of gray, to create tones, and added them to every color as well—wow! Can you imagine how many colors we could create just from our three primaries plus black and white? Hundreds! And what if we bought additional primary reds, blues, and yellows and mixed a color wheel with them, adding the blacks and whites; and then recombined the assorted primaries so we used different reds, yellows, and blues together. We could mix, literally, millions of colors. It boggles the brain! The color wheels on pages 24 and 25 give a small idea of what happens when we interchange primary colors.

Paint Your Own Color Wheel

To mix colors for your first color wheel, try to use the clearest, purest red, yellow, and blue you can find. Otherwise, you may end up with some colors that are a little disappointing if they're not what you hope or expect to get. For example, there are reds that have a slight orangish cast. If you mix them with blue to make a violet, you will get a brownish violet. And it will be even more brown if the blue you use has a slightly greenish cast. In both cases, even though you are mixing only two paints (red and blue) you are actually mixing all three primary colors together because both the orangish red and the greenish blue already have yellow in them. While the mixture may not be exactly what you had hoped for, it will still be a lively color (a tertiary color, in fact, so called because it includes all three primary colors). It can be an excellent shading and toning color, with much more life to

it than using a premixed brown or a black, which tends to deaden colors.

On a piece of sturdy paper (watercolor paper, poster board, or Bristol board) draw a circle about 7 inches in diameter. Divide your circle evenly into twelve pie-shaped segments and write in numerals as on a clock face. Now you're ready to paint your color wheel as shown on the next page. Each time you mix two colors together for the color wheel, try to create a color that appears visually to be exactly halfway between the two colors used in the mixture. For example, in mixing red and blue to make violet, be sure the violet does not appear more red or more blue, but rather just pure violet. It may be hard to see what color you have since it will be very dark. Spread a little of the mixture thinly on your white palette paper to check it before adding it to your color wheel. If it's too reddish, add more blue, and vice versa. Remember: Adding a medium to your paints will prolong their drying time.

Imagine the color wheel to be like the face of a clock. We'll use the three primary colors (at twelve, four, and eight o'clock) to mix colors to cover all the remaining numerals, and then some!

Primary Colors

In painting, the three primary colors are always red, blue, and yellow. To create our color wheel, we'll use the following DecoArt Americana acrylic paints:

- Primary Red
- True Blue
- Yellow Light

Note that other disciplines work with different sets of primary colors. For example, printers use cyan, magenta, and yellow. Physicists, working with lights, use green, blue, and red as their primary colors, mixing these to create the remaining spectrum colors.

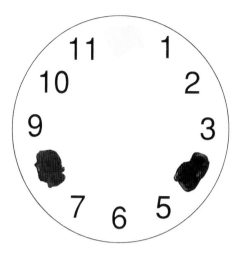

The primary colors cannot be mixed; they must be purchased. Place them on the twelve, four, and eight as shown. The primary colors are red, blue, and yellow.

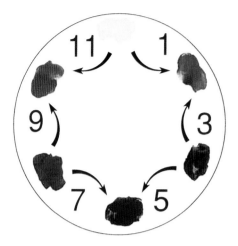

The secondary colors are created by mixing any two primary colors, and are placed between those two primaries (on the remaining even clock numerals). The secondary colors are orange (red + yellow), green (blue + yellow), and violet (red + blue).

The intermediary colors lie in between the primary and adjacent secondary colors with which they are mixed. The intermediary colors are yellow-green (yellow + green), green-yellow (green + yellow), green-blue (green + blue), blue-green (blue + green), blue-violet (blue + violet), violet-blue (violet + blue), violet-red (violet + red), red-violet (red + violet), red-orange (red + orange), orange-red (orange + red), orange-yellow (orange + yellow), and yellow-orange (yellow + orange).

The tertiary colors are created by mixing any two secondary colors; thus each tertiary color includes all three primary colors. Tertiary colors include, among others, citrine (orange + green, thus [red + yellow] + [blue + yellow]), russet (orange + violet, thus [red + yellow] + [red + blue]), and olive (green + orange, thus [yellow + blue] + [yellow + red]). We can also mix subtle variations.

Hint

When creating intermediary colors, mix two variations (as I did above): one having more of the primary color, the other having more of the secondary color. Put both mixtures in a single space on the odd clock numerals (for example, yellow-green at one o'clock, close to the yellow; green-yellow also at one o'clock, close to the green.) The first color in the compound name is predominant in the mixture.

Color Wheel Variations

Each primary color affects all the colors between it and the next primary color. For example, we find red in the mixtures on the three clock numerals both between red and yellow and between red and blue. Look what happens when we exchange our pure primary colors (red, yellow, and blue) with ones that are slightly different.

Note that I have not divided the intermediary colors into two portions on these wheels. You can imagine how the colors on the odd clock numeral spaces would look if each half of the color had a little more of its neighboring color added to it.

After painting your pure primaries color wheel, make additional wheels substituting different reds, yellows, and blues. Jot notes on the colors you used. That way, if you don't have a color suggested for a particular lesson, you'll have a record of how to mix something close.

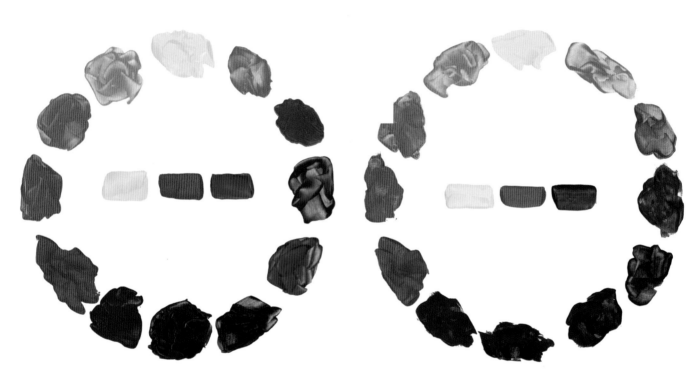

Color wheel created from three pure primary colors for comparison.

Here I replaced the primary blue with a blue having a slight greenish cast. The red and yellow remain the same. Observe how the different blue affects all the colors from one o'clock through seven o'clock.

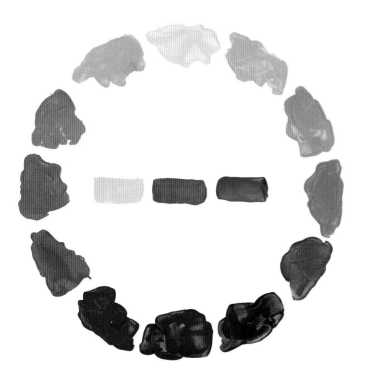

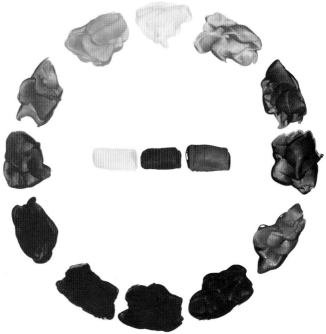

In this color wheel I substituted a soft, muted yellow for the original bright yellow. The red and blue remain the same. Notice how the yellow has affected the three colors on either side of it. Half of our color wheel now is pastel, and the other half contains intense, deep colors. We may want to add a touch of white or creamy yellow to the lower half of the wheel to both tint and lower the intensity of the remaining colors.

Here I kept the original blue and yellow and changed the red. Now we have lovely muted reds, oranges, and violets. If we add to the blue and yellow—and their mixtures—a little of their complementary colors (more about them, soon), the entire color wheel would be made up of low intensity, but lovely, colors.

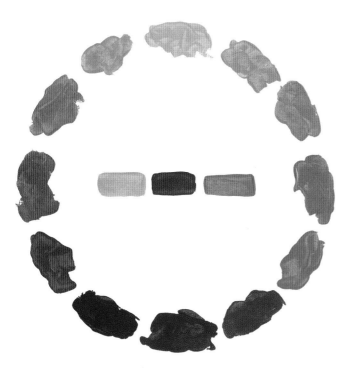

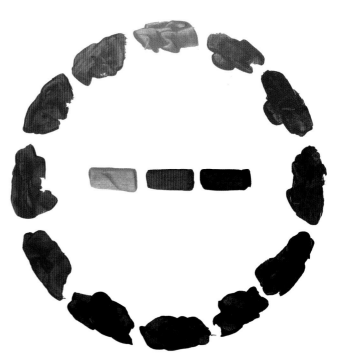

I replaced all three primary colors in this color wheel. Look at the violet mixtures at five, six, and seven o'clock. They are very grayed. And little wonder: Both the red and the blue contain a good bit of yellow. Thus, when mixing the red and blue to get violet, we've also included the third primary color, yellow; and three primaries mixed together result in a dull, low intensity tertiary color. But doesn't the entire color palette look interesting?

This figure shows another lovely, muted palette. All three of these primary colors are different from our original three. These three primaries give us deep, rich mixtures.

COMPLEMENTARY COLORS

Now let's see what exciting things happen in the world of color when we take some of our mixed colors and mix *them* together. Colors that are located directly opposite each other on the color wheel are called "complementary colors." Look at your color wheel or the one on page 24 (use the one made up of pure primary colors). What color is directly across from

yellow? from blue? from red-orange? If you answered violet, orange, and green-blue, respectively, you get a smiley face. It's good to learn, early on, what the complement is of every color. That knowledge enables us to mix beautifully subdued colors, to place certain colors adjacent to others in our painting for strong impact, and to create engaging color schemes.

Finding Complements

A pair of complementary colors consists of all three primary colors: red, blue, yellow. Choose one of the three primaries (for example, red). To determine its complement, mentally mix the remaining two primaries together (blue + yellow = green).

Therefore, the complement of red
is blue + yellow and vice versa.

Likewise, the complement of
blue + red is yellow and vice versa.

Remembering Complements

Until you have memorized the locations of colors around the color wheel, or the pairs of complementary colors, here are some memory aids and interesting facts to help you.

- An aid to memorizing the complementary colors—
 think of the holidays:
- Christmas—red and green
- Easter—violet and yellow
- Halloween—orange (pumpkin) and blue (sky)

- The complement of a primary color is always a secondary color and vice versa. Don't just take my word for it. Look at the color wheel and check it out.
- The complement of a cool color is always a warm color and vice versa. We'll explore temperature shortly. Just remember to come back to this statement and check it out on your color wheel, as well.
- The complement of a color can be found in its *afterimage*. If all else fails, stare at the color you need to know the complement of until your eyes start to fatigue. (Allow about 20 seconds or so. You'll see a slight, white halo appear around the color and your eyes may feel like they're crossing or looking right through the color.) Then shift your gaze to a white piece of paper or wall. After several seconds, you will see a faint afterimage in the complementary color. It takes some folks a while to learn to see the afterimage, so if you're not successful right away, don't give up. It's fun to do, and you can practice it anywhere, even in a crowd or during a boring meeting. No one will ever know!

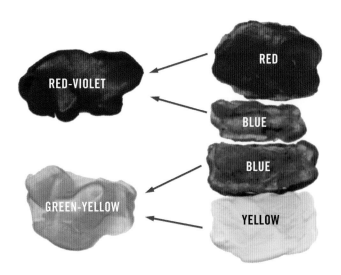

Finding the complement of red-violet.

Complementary Colors Do Neat Things!

Placing complementary colors side by side intensifies them, each one enhancing the other. Mixing complementary colors together neutralizes them, creating low intensity, subdued, grayed colors.

You can use both of the above attributes together to make your paintings really pop. Say you plan to paint an orange pumpkin. Put it on a blue background to enhance the orange. If you mix a little orange into the blue to subdue the background, its dullness will make the pumpkin appear even brighter.

The conscious use of complementary colors plays such an important role in our paintings that we will visit them again when we explore attributes of color such as value, intensity, and temperature later in this section; and when we discuss creating color schemes. If you don't quite get it yet, just review these pages once in a while. It *will* begin to make sense.

Notice how the violet and yellow swatches are intensified by their proximity to each other.

Cover up the colors on the left side of this page, then stare at the blue ball above. Next, quickly shift your gaze to the empty box below for a few seconds and wait for the afterimage to appear. What color is the ball? What color are the stripes?

Violet and yellow combined become gray.

Playing in the Mud

Just imagine all the different colors of mud there must be around the world. Wonderful colors. Yet, when we mix a color that disappoints us, we often call it "mud." Well, it's time we showed a little more appreciation for these beautifully subdued, low intensity colors. They have oodles of uses in our paintings. They can actually save a painting from becoming a hodge podge of too many active colors trying to show off how pretty each is. They can unify a painting that looks like a jumble of unrelated things with not a thread to hold it all together. But we need to understand how those subdued colors happen, and how we can control them; making them happen when we want, and how we want them, and preventing them from happening when we don't want them.

If you've been reading carefully and thinking about what we've covered so far, you know that creating those low intensity colors involves mixing all three primary colors together. When one or two of the three primaries predominate in the mixture, we call it a tertiary color, which is, indeed, what we get when we mix two complementary colors together. When all three primaries are in approximately equal visual amounts, it's hard to distinguish any particular color. (Alright, it looks like mud.)

We can learn tremendous color mixing lessons from working with a pile of muddy looking paint. So let's play in the mud.

1. Squeeze out a bit of all three primary colors and add some medium to prolong their drying time. Then, mix them together. Now, let's try to adjust the color of the pile of paint to make a rich, dark, neutral gray. But first, we need to see exactly what color we're starting with. Depending

upon the intensity of your paints, you may have a very dark pile of paint there.

2. With your finger or a palette knife, drag a small amount of paint from the edge of the pile. Mix a little white into it. This will make it easier to see what color is predominant in the mixture.

3. Now add a little of that color's complementary color. If the color smear is a brownish red, mix a very small amount of green into the pile. Then test it again. If the smear looks more bluish, mix in blue's complementary color, orange. And so on. Keep working until you create a gray that appears perfectly neutral—not too red, not too blue, not too violet, orange, yellow, or green. Think about every addition you make to be sure you're adding the complementary color. And, add it sparingly, testing with white on a small smear after each addition. Don't just carelessly dump colors in the pile. You won't learn a thing but how to make that proverbial mud. Instead, make a conscious effort to understand what's happening, and to study each variation of gray you mix. You will see some gorgeous colors when you stretch them out with a little white. You might even want to save swatches of the mixtures to remind you later of the lovely grays you're capable of mixing. Don't just read about it, do it! It's the only way you'll learn.

Hint

If you're painting a composition you wish to appear warm, try mixing a little reddish-gray with all the hues you use in that painting. Use the bluish-grays to create a cooler impression. If there is something in the painting you really want to stand out, do not mix the gray into its colors. The contrast of intense colors against the slightly grayed colors will put that subject in the spotlight!

You can create an array of lovely neutrals from a seemingly dull pile of "mud."

THE FOUR PROPERTIES OF COLOR

There are four properties of color, which we need to understand in order to use color successfully in our paintings.

They are:

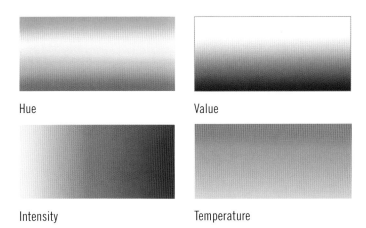

Hue

Value

Intensity

Temperature

Hue

Hue is simply another word for color. What hue is it? What color is it? We have already discussed the names of the spectral hues in our study of the color wheel. Those names, combined with the other properties we're about to explore, will help us to accurately describe any particular color.

Value

Value refers to the lightness or darkness of a hue—its relationship to white, black, and the grays in between. For example, pink is a light value hue; burgundy is a dark value hue. The American portrait painter and teacher Albert H. Munsell (1858–1918) determined there were nine distinct, equidistant steps of gray between black and white. The value scale he originated bears his name.

Tints, Shades, and Tones

By adding white or black, we can raise or lower the value of any hue. The addition of white raises the value and creates a *tint*. The addition of black lowers the value and creates a *shade*. Adding a mixture of black plus white creates a grayed *tone*. A tone can also have nine values; more black in the gray mixture would make it a lower value; more white, a higher value.

Effects of Surrounding Values

Take a look at the value scale at right, paying particular attention to the dots. At first glance, it appears that the dots grow lighter as they proceed down the scale. Wrong! After I finished painting the nine equidistant steps of gray, I took a bit of the middle value gray (No. 5) and painted a dot of that value on each step of the scale. This is a

reminder that every hue and value we paint is affected by the hue and value we paint around it. If we paint something dark next to a light object, it will make the light object seem even lighter. Sometimes in painting, if we can't seem to get our lights light enough, we must switch our attention to the darks and push them darker. The contrast will make the lights appear lighter. This effect of contrasts also works with intensity and temperature, which we'll explore shortly.

		HIGH VALUES	
LIGHT VALUES	WHITE		●
	9		●
	8		●
	7		●
MEDIUM VALUES	6		●
	5		
	4		●
DARK VALUES	3		●
	2		●
	1		●
	BLACK		●
		LOW VALUES	

The Munsell value scale specifies nine equal and equidistant steps of gray between pure black and pure white. Pure black is placed at the bottom of the Munsell value scale, and is designated as 0. Each addition of white or light color to that pure black would raise its value upward on the scale. Munsell determined that mixing black and white together would produce nine different shades of gray, each the same interval apart from their neighbors. The numbers simply indicate the position on the scale: The higher the number, the lighter the value.

Value and the Color Wheel

Refer to the basic color wheel on page 24 and compare the positions of the pure hues as they progress down the wheel. Notice that the lightest hue, yellow, is at the top of the wheel, and would be near the top of the value scale. The medium value hues—oranges and greens—are midway down the wheel and the scale, followed by the somewhat darker hues, red and blue. Finally, the violets or purples, our dark value hues, are at the bottom of the wheel and also the value scale. Make a black and white photocopy of your color wheel and check this out.

Adjusting Values

Thankfully, the hues don't have to remain in the positions (just described) on the value scale. We can adjust any of the hues and move them up or down the value scale by adding a little of a hue that is above or below it on the color wheel. We can move the hues even higher, to the top of the value scale, by mixing them with plenty of white. Likewise, we can move hues further down the value scale by adding black. We just must realize that the hue may shift. For example, black added to yellow will turn it a greenish hue. To keep yellow in the yellow family, we would need to lower its value with brown, or with its complement, violet. Likewise adding white to hues can sometimes make them look chalky. For instance, adding white to red results in a sugary pink. If you want a light red, instead of "cotton candy pink," add a bit of yellow with the white to lighten the red.

The Key to a Painting

Key is a word that describes a collection of related values. Just as a piece of music is said to be in a minor or a major key, or in the key of C or F—in other words composed of a collection of related notes or tones—a painting is also described as being in a certain key. A *full key* painting uses all nine values on the scale plus black and white. A *high key* painting uses just the values on the upper part of the scale plus white. A *low key* painting uses just the values on the lower part of the scale plus black. A *middle key* painting uses just the values in the middle of the scale.

When we look at a painting, our first perception is its lightness or darkness. From that initial, brief glimpse—even before noting the subject matter—we may develop an impression or have an emotional reaction to the painting. Think of a favorite painting. Determine its overall lightness or darkness. Now imagine it painted in different values. A high key painting (that originally appeared cheerful, bright, and positive) becomes ponderous, heavy, mysterious, maybe oppressive when shifted to the lower, darker values.

Now imagine the most depressed scene you can. You would probably paint that scene in predominately dark hues, and grays and blacks. Slide that same mental picture up the value scale and the immediate reaction (until the subject matter was recognized) would not be one of gloom. Noting the light values of the hues, the viewer would expect a more lighthearted theme. Once the response to the lightness or

darkness of the painting has registered, then the viewer must reconcile it with the emotional response to the painting's content. We have power over how the viewer responds to our paintings, but we have to know how to use that power to accomplish our purposes in creating the painting.

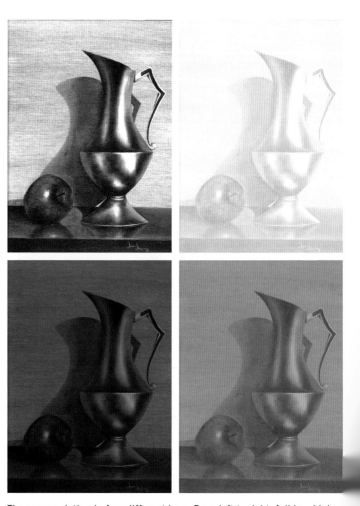

The same painting in four different keys. From left to right: full key, high key, low key, and middle key.

Intensity

Intensity refers to the brightness or dullness of a hue and is sometimes called its "chroma" or "saturation." Intense color is fully saturated, pure, strong, brilliant, and unaltered by the addition of other pigments. Used thoughtfully, a very intense hue surrounded by hues of lesser intensity can be riveting. Beware, though, that the use of too many fully saturated hues in a painting can be disconcerting and can weaken it.

Lowering Intensity

Mixing complementary colors together neutralizes the colors or lowers their intensity. An easy and effective way of lowering the intensity of color is to mix it with a little of its complementary color (the color opposite it on the color wheel). In a yellow apple, for example, you can lower the intensity of the yellow by mixing in violet for its shadow areas. Remember that a pair of complementary colors, between them, contains all three primary hues. And when all three primaries are mixed together (in equal amounts) we get a neutral color.

Increasing Intensity

Placing complementary colors side by side intensifies their colors. Placing a fully saturated color beside—or surrounded by—its complementary color, which has been lowered in intensity, makes the saturated color appear even brighter. So if you've painted a red apple and you want it to nearly "pop" out of the painting, surround it with a green of lowered intensity.

Understanding how great a role intensity can play in our painting helps us use it effectively both to accentuate the focal point and to lead the viewer's gaze.

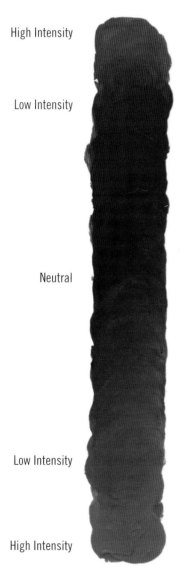

High Intensity

Low Intensity

Neutral

Low Intensity

High Intensity

...xing a color with its complement lowers its intensity. On either end ...the neutral color in this mixture, we can see the gradually lowered ...ensities of the red and the green. Use your hands to cover all but a ...all section of the strip as you study it.

The same bright red has been placed on three different colored backgrounds. Notice how those surrounding colors affect the red. The bright green (top) competes with the red for attention. The green's intensity almost makes the red appear dull. The low intensity green (middle) makes the red appear intense. That bright red all but disappears, however, when placed on its neighboring color, orange (bottom).

Temperature

Temperature refers to the suggestive effect of warmness or coolness of a hue. Warm colors (red-violets, reds, oranges, yellows with a slight orange cast) seem to advance, or come forward. They are energetic, agitated, passionate, athletic, reminiscent of fire, sun, and heat. Cool colors (blue-violets, blues, greens, and yellows with a slight green cast) seem to recede, or move away. They are quiet, pastoral, restful, reminiscent of sky, water, distance, and open space. Understanding colors' advancing and receding effects further enhances our ability to manipulate colors to suit our purpose in a painting.

Relating to the Color Wheel

Look at the color wheel. If you draw a line through the diameter of the circle, slicing into the yellow and the violet, the hues to the left of the line are warm colors; those to the right of the line are cool colors. The yellow and violet are just about neutral in temperature; but they can be easily shifted from warm to cool by the slight addition of an intermediary hue to either side of them.

Now, notice what happens when we select the complement of a color: The complement of a warm color is a cool color; and, conversely, the complement of a cool color is a warm one. You will notice that in each pair of complementary colors there is a warm and a cool color. Check it out on the color wheel.

Paint a Mental Picture

Suppose you wanted to paint a brass vase full of yellow tulips. How would you work with temperature (as well as, of course, with intensity, value, and hue)? Consider how you might treat the background to show off the tulips. What hue and what kind of texture would you choose? Would you make the background warm or cool? With what? Would you warm the yellow of the tulips? How? The brass vase, if you let it reflect all the wonderful hues surrounding it, could steal the show from the tulips. How could you make the tulips more eye-catching? Lots to think about!

Hopefully by now you can think in artistic terms, which should give you a bit of confidence. Don't worry if you don't master it all right away. Just keep reviewing the material and trying to sort out the possibilities every time you paint. Make a point of trying to describe hues, when thinking or speaking of them, in terms of their value, intensity, and temperature, rather than in the clever names manufacturers give them—like "purple passion fantasy," and "desert grass green." To tell a friend we painted a room "toasted persimmon" would leave the friend wondering: What hue does a persimmon turn when it's toasted? Is the room now a bright orange, a deep, dark orange, a brown? But if we say the hue is a medium, dull, warm orange, we are more accurately describing the value, intensity, temperature and, thus, the hue.

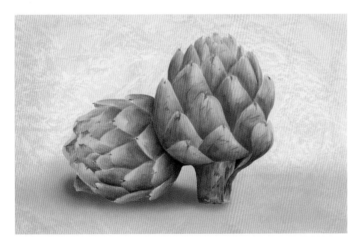 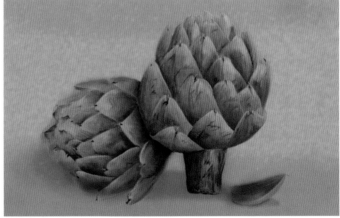

Look what happens when we paint the same artichokes with slight shifts in temperature: warm (left) and cool (right).

Traditional Color Schemes

There are several traditional color schemes, each having color combinations that are either adjacent (neighboring colors on the color wheel) or contrasting (colors opposite one another on the color wheel). The most common color schemes are monochromatic, complementary, split complementary, analogous, and triadic. In addition to a combination of hues, a color scheme can also include tints, tones, shades, and altered intensities of those hues. Select one color from the scheme to dominate, either in value, intensity, detail, or area, or a combination thereof. Avoid using all the colors in the scheme at their full intensities unless you're aiming for a jarring effect, or trying to create a circus-like atmosphere.

The monochromatic color scheme includes variations on a single hue, in this case green.

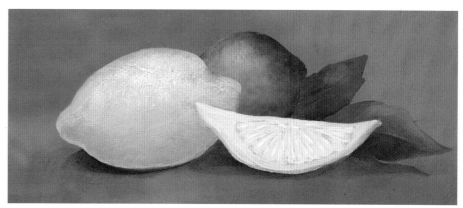

The analogous color scheme includes any two to seven (if you count the intermediary mixtures each as two) adjacent colors on the color wheel. This sketch shows yellow, yellow-green, green-yellow, green, green-blue, blue-green, and blue.

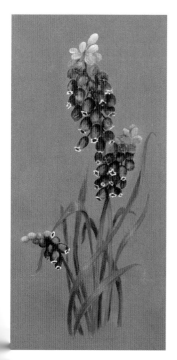

The triadic color scheme includes three colors equidistant from one another—in this case, a subdued orange, violet in strongly contrasting values, and green close in value to the orange).

The complementary color scheme includes two diametrically opposed colors (in this case red and green). Note that even though the green background in this sketch comprises a greater area than the pomegranate, it is of a lowered intensity, thus allowing the bright red of the pomegranate and its busy detail and value contrast to dominate.

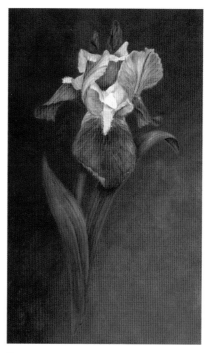

The split complementary color scheme includes a key color and the two colors on either side of the key color's complement. The colors featured in here are yellow, red-violet, and blue-violet. In the iris, the most eye-catching color (because of intensity, temperature, and value contrasts) is the yellow, even though it's small in area. The green, though larger in area, blends in with the background and is thus less important.

Seeing Color Harmonies Around Us

Color schemes are everywhere we look. Unfortunately, we often don't see the trees for the forest. (No, that's not a malapropism.) We miss the details right in front of our eyes because we're caught up in the bigger picture. Let's take apart those "bigger pictures" and look for the details. We'll see that there are lovely color schemes in things from walls to rooftops, flowers to butterflies, skies to fields, threatening storms to delicate roses. We have only to look and really see!

When you're stuck for color scheme ideas, look through these pages. I have isolated many hues in each photograph.

These can be used in creating color schemes for painting anything from the subjects in this book, to landscapes, portraits, even abstract paintings. Not every hue in a selection need be used. (Often, the fewer we use, the better.) In fact, if you study the photographs, you will find additional hues that, due to space constraints, were omitted. You may even decide that a slight shift in intensity or value in a hue would suit you better.

Things to Consider

Ask yourself the following questions before deciding on a color scheme for your painting.
- What value do you want to be dominant (light, medium, dark)?
- Do you want a dark value composition on a light background or a light composition on a dark background?
- Do you want a strong or weak value contrast between the background and subject matter?
- What temperature do you want the dominant hue to be (warm or cool)?
- Do you want to use harmonious, similar hues or contrasting, complementary hues?
- What sort of intensity contrast do you want (weak, moderate, strong)?
- What mood do you want to create?

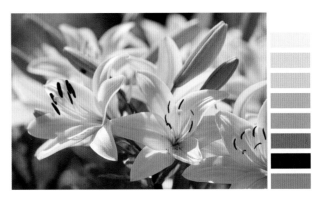

Imagine that you want to paint a bunch of bananas. Look through the photos in this section. You'll see several variations of yellow—from bright to creamy to low intensity to yellow-orange. Choose one of the yellows. Then imagine how you might use some of the other colors from the same photo to finish the painting. Try it again with hues from another photo. Can you picture a rendering of the bananas using the blues, beiges, and browns of this stormy sky picture? Too dull? You might want to brighten the dull yellow hue slightly. Let the colors in these pages inspire you but not limit your imagination.

As long as our vision is clear, our brain is bombarded continuously with color harmonies. All we have to do is remember to see. Some people listen without hearing. We must be careful that we don't miss the beauty of color because we look without seeing.

THINKING ABOUT COLORS

Color choices can contribute to our paintings or detract from them. They guide the viewer to see what we want to be seen, or direct the viewer's eye elsewhere. They emphasize our subject matter, or call attention to themselves. They cause the viewer to linger longer, or send the viewer scurrying. They create a mood or a feeling, or just express, "Ho hum." And the scary thing is: The choice of colors and treatment is totally up to us. On the other hand, that's also the most exciting part of painting.

Using Color to Create a Mood

Colors have a profound effect on our emotions. Even if you have never painted, you already have some sense of color. See how easily you can conjure up colors to paint a circus scene, or a funeral. You get the idea. We readily associate some colors with certain circumstances, events, and emotions. Those color associations will, of course, be influenced not only by our individual and emotional preferences, but also by our cultural heritage. (For example, white is associated with mourning in China; in the United States, with weddings or purity.)

Make a list of some moods, sensations, and attributes, like aggressive, angry, comfortable, confused, delicate, energetic, fresh, happy, immature, innocent, melancholy, passionate, peaceful, pure, romantic, rustic, somber, tranquil, etc. What hues, values, and intensities do they suggest to you? Use this list later when you hit a creative block or are unsure what mood you would like your painting to reflect.

If you need to jumpstart your imagination for this exercise, look through a book of paintings—preferably one that spans many painting eras. Look with squinted eyes so you're less likely to be influenced by the subject matter. What feeling does the general color, value, and intensity of each painting engender? And which of these color applications are you most drawn to? Some of us prefer colors in strong opposition to one another, such as blue and yellow. Others find the strong opposition of colors jarring, and prefer more muted or grayed colors, or colors that lie closer to one another on the color wheel, or colors in fresher, cleaner, lighter tones. What do you like? Do you always like the same thing, or are there times when you're more drawn to something totally opposite?

Color Scheme Exercises

Of course, the best way to learn about painting color harmonies is to work with paint; but we needn't be limited to that one recourse. Listed below are several activities that will joggle the color cells in your brain. You will need, in addition to your painting supplies, a stack of old magazines, photographs, postcards, a sheet of clear acetate, scissors, and a package of colored construction paper—preferably one that has a wide range of colors, values, and intensities. From the package of construction paper, select one sheet of each value and intensity for every color. Cut the sheets in half crossways. Keep one set of half-sheets to represent different background colors. Use the other set to cut into shapes in the second exercise.

Choose a background color. When you need help selecting a background color for a painting, grab your paints and make color swatches—or a quick sketch—of your intended subject on the clear acetate. Hold the acetate against various colored papers. Pick the subject/background color combination that pleases you the most and that will support the effect you wish to accomplish. Keep in mind that you will probably need to adjust the hue, value, or intensity of that background color somewhat in the actual painting. Sometimes, a slight shift in value or intensity means the difference between a background color that supports your design and one that competes with it. Wipe the acetate clean to reuse.

Collect colors. Start a collection of travel and art postcards and photographs. Collect not only pictures with color schemes that please you but also ones that would cause you to broaden your taste for other color harmonies. You'll be surprised at how inspiring it can be to have a ready supply of color schemes.

Keep a notebook. Keep a looseleaf notebook in which you paste snips from magazines, ads, wallpapers, printed fabrics, wrapping papers, and so on. Or attach them to large poster boards. Try to analyze each entry to see what it is about that particular combination of colors that tickles your fancy. The more you analyze your reaction to the colors you see used together, the more at ease you'll become in creating your own color harmonies.

Take note. Buy a set of colored pencils and a small sketchbook. Carry them with you on trips across country, around the world, or just to the garden, local nursery, or museum. Make notes of interesting color combinations.

You will need:

- Craft clay or Play-Doh (clay should be a solid color)
- A light source (flashlight, desk lamp, table lamp, sunlight through a window)
- Toothpick or small twig
- Colored papers
- An orange and/or assorted objects and fruits
- A value scale (see page 29)

LIGHT AND SHADOW EXPERIMENTS

The mystery of light and shadow, and how they react with one another is a fascinating case, with clues scattered all around us. With just a few tools, we can solve the puzzle; and doing so will have a great impact on the effectiveness of our painting. To learn from this chapter, you're going to have to do some experiments. We learn best by doing.

Local Color, Shadows, and Highlights

Let's imagine, for a moment, that our clay is a new chunk of orange craft clay. We know that the piece of clay is the same color throughout—no variations, no light tints, no dark shades. The clay's color is called its *local color*. The following exercises will help you to see and understand local color as well as *highlight* (the area facing the light), *shadow* (the area facing away from the light), and *half-tones* (those subtle shifts in value between the highlight and shadow areas).

1. Roll the clay into a smooth, round ball, place it on a piece of paper, and shine a light on the upper right side. We know the entire ball is the same color throughout because we formed it ourselves from a single color clay. And yet, if we look carefully and compare, we can see that the ball is no longer that single, local color. The local color appears slightly washed out where the light hits it, and much darker where the light is absent. Look at the half-tone area—the area on which the light glances past at an angle rather than striking directly. Use your value scale to see how many values you can identify on the ball.
2. Now poke your finger in the top of the clay ball to make a depression. Set the ball back on the paper and beam the light across the top of it. What happens when the light shines across the depression? Which side of the depression is the highlight on? Which side is in shadow?
3. Next, push a toothpick or twig down in the depression, kind of like a stem.

4. Now, gather several solid-colored objects, any shape. Shine a light on each one separately. Look for the light and dark values and compare them with the local color. Use your value scale to try to determine the values of the local colors, the shadows, and the highlights.
5. Check the highlights against the pure white on your value scale. Are they a stark white? Try to determine whether the highlight colors are warm or cool.

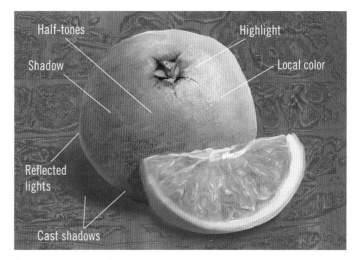

Observe how the local color changes depending on where the light hits the orange.

Cast Shadows

We can further add to the three-dimensional perception by painting a cast shadow. *Cast shadows* are shadows caused by an object blocking the flow of light. Let's return to the clay ball and this time study the cast shadow.

1. Once again, shine the light on your clay ball. Notice the position and shape of the cast shadow. Move the light source around, raising it higher and lowering it. Place it directly above the ball.

2. Try the first experiment again, this time using a collection of other objects of various shapes. By paying attention to ordinary things in everyday life, we become more aware of cast shadows and how they're affected by the objects they fall across.

3. Rotate the paper on which your arrangement sits and observe the changes in the shapes of the shadows.

4. Set up your arrangement on a piece of white paper near a south facing window and check it periodically. Watch what happens to the shadows as the sun rises higher in the sky, or sinks, or fades.

5. Now let's look for even finer details. Select a few of your objects, and under the light, study the edges of the shadows. Move the light source closer and then farther away. When is the shadow's edge sharp? When is it more fuzzy? When is the shadow darkest? When is it faint?

6. Unless you're working in the dark with just a single light source, you will probably see other cast shadows, as well. See how many cast shadows you can find for a single object. What happens when two of those shadows overlap? Each shadow cast by a single object represents a different light source. See if you can identify which light source caused each shadow you see.

7. The cast shadow is affected by the color of the surface on which it falls. Place your object on different colored backgrounds. What happens to the color of the cast shadow? To more easily compare, let the object's shadow fall partially across two or three different colored pieces of paper at the same time.

8. The cast shadow is also affected by the color of the light that casts the shadow. Place an object on a piece of white paper near a south facing window. Make careful note of the color of the cast shadow in the cool light of early morning. Check on it again later in the afternoon when the light is warmer in color.

9. The next time you attend a performance where colored spotlights are used, notice the colors of the shadows that are cast. Security and streetlights will also cast different colored shadows. As you walk from one lighted area to another at night, watch the color of your shadow. In fact, try to become aware of the colors in every shadow you see.

10. Sometimes an intense light will cast a shadow the same color as the object, especially that part of the cast shadow that is closest to the object casting it. Try this: Outside, in bright sunlight, place an orange, an apple, and a lemon on a sheet of white paper. Arrange them so you can see each cast shadow separately. If your eyes aren't trained to notice subtle color variations, you may, at first, simply see a dark gray cast shadow. Look again. There are wonderful colors hiding in those shadows.

11. Place all the fruit on a piece of colored paper. Place the lemon slightly behind the apple. Shine a light on the apple, letting the shadow from the apple climb up onto the lemon. Notice how the shadow of the apple changes shape to wrap itself onto the contours of the lemon. And what color is the shadow cast onto the lemon?

Notice the beautiful colors in these cast shadows. For the orange, look for orange, red, and violet. For the apple, look for deep violet and blue.

Study the bottom edges of these fruits. Notice how light their color is from the yellow background reflected back up onto them.

Compare how much darker the lower edges of the fruits are now on the background. Study the transition of colors on the orange, from washed out color in the highlight area, to yellow, to yellow-orange, to orange, to red-orange, to red, and to violet along the lower edge.

Reflected Lights

Reflected lights are lights that are reflected off of nearby surfaces onto an object. The smoother, glossier, and shinier the nearby surfaces are the more likely they are to reflect light onto neighboring objects; a matte, dull surface would absorb much of the light. The reflected light is subtle—neither as strong nor as large as the true highlight area. It will be located adjacent to the surface reflecting it.

1. Place an orange on a yellow surface. Notice how the light that strikes the yellow surface bounces back up onto the orange's surface. That reflected light area will be a light yellow-orange, located near the edge of the orange, and close to the cast shadow. Your brain is telling you, "The orange is orange, and that's that." Experiment with different colors and with both shiny and matte surfaces until you find a combination that finally helps you see the reflected light. Once you begin to actually see a reflected light, it will become easier to recognize in the world around you.

2. On your yellow background, place a red apple, and a lime, or some other object near your orange. Can you see their colors reflected onto the adjacent surface of the orange? So now your orange has not only its local color, its washed out highlight color, its half tones, and its shadow colors, it has also colors of the surface on which it sits and colors of the objects surrounding it. But one of the wonderful things about objects being more than just a single local color is that we can use all those other colors to unify the subjects in our paintings. Reflected lights and cast shadows help us build connecting paths of color between the various subjects, thus helping the eye travel through the painting.

3. Now try a few white eggs on different colored backgrounds. See if you can identify the reflected lights using just the available light in your kitchen.

4. Put several white eggs on a white napkin, in a white bowl, on a white tablecloth. Look for all the colors hidden in all that white. For extra credit, after you have worked through several painting lessons, try to paint the eggs. You'll learn invaluable lessons while trying to capture the different whites in all their colors. Have fun!

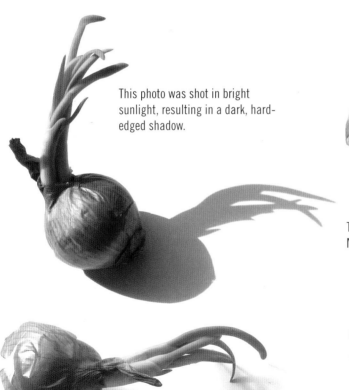

This photo was shot in bright sunlight, resulting in a dark, hard-edged shadow.

This photo was taken a few moments later under an approaching cloud. Notice how the density of the shadow changes.

A few more moments later, and a lot more cloud. This soft edged, lighter value shadow illustrates how much the cloud had filtered the sunlight. Softer light, softer shadow.

The closer an object is to the surface on which its shadow falls, the closer it will be to touching that portion of its shadow. Notice that the sprouted leaves that touch the surface also touch the shadow. (Look for the bit of green reflected in the shadow where they touch.) The leaves that are farther away from the surface are also father away from their cast shadow.

Some Things to Remember

The list below will remind you of some of the things you should have discovered through your light and shadow experiments. If you haven't worked through the experiments yet, don't peek!

- A gentle light casts a fuzzy shadow.
- A bright light casts a dark shadow.
- A far light casts a soft shadow.
- A close light casts a hard shadow.
- A far light casts an elongated shadow. (Sunlight low on the horizon makes our personal shadow long, lean, and lanky.)
- A near light casts a condensed shadow. (Sunlight directly overhead makes our personal shadow short, squat, and stout.)
- Shadows are darkest near the object casting them.

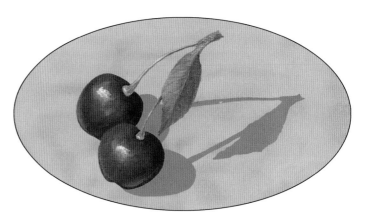

What kind of light casts a hard, long shadow like this?

Hints

- Walk around the arrangement to view it from different vantage points. Try removing and replacing objects while watching the adjacent surface to note subtle color changes. Try it under different lighting.
- To easily paint reflected lights and cast shadows, first slightly moisten the area to be painted with water or water plus an extender medium. Then sideload a flat brush (larger than you think you need) with color thinned with water and extender medium. Stroke the brush on the palette (over and over in the same spot) to blend the paint partially across the brush. Apply the stroke to the painting, using the water edge of the brush, if necessary, to soften any unwanted hard edges. Resist the temptation to keep fiddling with it. If your application appears too weak, dry the paint completely, then repeat the process. It's much better to apply too little paint than too much. You can easily build up depth of color with repeated layers, but you cannot as easily remove too heavy an application.
- Keep a strong flashlight or high intensity desk lamp handy at your painting table to experiment with lighting variations when you're painting from actual subject matter.

- Shadows fade the farther they are from the object casting them.
- Shadow colors are affected by: the object casting them; the surface color upon which they are cast; the objects surrounding them and reflecting light onto them.
- Some shadows may be cool; others, in the same arrangement, may be warm.
- The shadow's shape is affected by: the object casting the shadow; the shape of the object on which it falls; the proximity of the light; the angle of the light.
- Where light strikes, local color is washed out.
- Where no light strikes, local color is darkened.
- Where light is obstructed, a shadow is cast.
- Multiple light sources cast multiple shadows.
- When light passes across a depression, the highlight hits the far side of the depression; the shadow falls into the side of the depression nearest the light.
- Where multiple cast shadows overlap, the shadow will be darkest.
- Sometimes cast shadows will be the complementary color of the light causing the shadow.
- Light reflected by nearby objects onto a subject will affect the subject's local color.
- Highlights are rarely pure white. They may be warm or cool. To make a highlight seem stronger, contrast its temperature with that of the subject's local color. (For example, put a slightly greenish highlight on a red apple or a yellowish highlight on a purple grape.)
- To make a highlight seem lighter, paint the subject's local color darker.

COMPOSITION DESIGN FUNDAMENTALS

Just as knowing the letters of the alphabet enables us to build words, knowing the elements and principles of design and the effective placement of the focal area will help us build successful compositions. These fundamentals have long been recognized and used by artists, designers, and decorators.

Elements of Design

A design is made up of six elements: *line, shape, size, space, color, value, intensity, texture,* and *mass*. If you dissected even a child's crayon drawing, you would find these elements. In describing the elements, I have listed a few descriptive terms—sometimes of opposite extremes (light/dark, large/small, etc.). Not listed, but equally important, are all the variations between, and even beyond, the descriptions (very light, medium light, medium, medium dark, very dark, etc.). The descriptions are meant to inspire your thinking, not limit it to the few adjectives mentioned.

- **Line:** Straight or curved? Flowing and free or rigid and decisive? Horizontal (resting, tranquil), vertical (strong, rigid), or diagonal (activated, energized)? Blurry or bold? Delicate or sturdy? Actual or suggested (by something pointing, looking, or facing)?
- **Shape:** Free-form, rectangular, square, triangular, circular, oval, organic?
- **Size:** Large or small? This can pertain to the objects as well as the spaces or intervals between them.
- **Space:** Positive (occupied) or negative (empty)? Advancing or receding? Open or closed?
- **Color:** Warm (advancing) or cool (retreating)? Opaque or translucent? Harmonious, contrasting, or discordant combinations?
- **Value:** Light, cheerful, and delicate or dark, threatening, and somber?
- **Intensity:** Saturated (full strength, brilliant) or unsaturated (muted, grayed, subdued) color?
- **Texture:** Shiny like satin or nappy like velvet? Smooth or rough? Busy with detail or plain?
- **Mass:** Large or diminutive? Vigorous or delicate?

Focal Area

As we make our design selections based on the various elements, we also need to determine a focal area for our painting. A focal area attracts attention and then leads the viewer to continue looking. The focal area can be emphasized by, among other things, painting it with the strongest value and intensity contrasts, giving it the greatest detail and sharpest definition, and having lines within the composition direct attention to it.

We must be careful, however, not to be too ambitious, trying to make our entire painting full of focal points. When everything in the painting is a focal point, there is no focal point. Water droplets painted on every leaf and flower are useless and distracting unless we're painting a rainstorm. On the other hand, one or two droplets placed strategically on only the focal area will draw the viewer's attention directly to it.

And how do we decide where to position the focal area? First, we need to decide what type of balance we want in the composition: symmetrical (in which both sides of the painting appear almost as a mirror image, with the focal area placed along the center line); asymmetrical (in which the focal area is placed off center); radial (in which lines converge on or radiate from the center); or occult (in which there is no obvious focal area). Since the focal areas for the symmetrical and radial compositions rest on the center line, and there is no obvious focal area in the occult composition, let's focus our attention on asymmetrical balance.

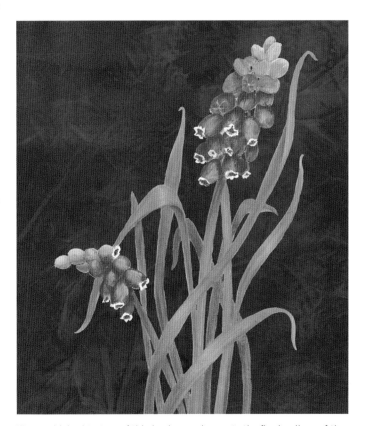

The marbleized texture of this background repeats the flowing lines of the grape hyacinth's strap-like leaves. The deep background color makes a striking contrast to the light flowers.

A quick and easy way to determine an ideal location for the focal area is to divide our painting surface into thirds, both horizontally and vertically. Any one of the four points at which the horizontal and vertical lines intersect would be an ideal location for a focal area. You will notice that any one point is located an unequal distance from the top and bottom of the illustrated rectangle and from the two sides. These same divisions can be applied to square or circular painting surfaces.

Principles of Design

The principles of design include dominance, contrast, rhythm and repetition, balance, transition, and unity. I have included a few thought-provoking questions or points with each principle, but, as with the elements, these questions or points are not meant to be all-inclusive. They are just to spur your thinking. Keep our hypothetical red rose (see sidebar at right) painting in mind as you read through these principles, and try to make some decisions relevant to how you might paint it.

Dominance

Dominance is that which first captures the viewer's attention. When designing a composition, ask yourself, for example, what will be the dominant . . .

- shape (horizontal, vertical, diagonal, circular, triangular)
- texture (smooth, rough, crisp, bristly, soft, stiff)
- color (warm or cool)
- intensity (subdued or brilliant)
- value (light or dark)
- line (curving or straight)

Contrast

Contrast is that which conflicts with the dominant shape, value, color, etc., thereby creating variety. A composition of all round fruits would be boring. Throw in a pineapple, all spiky and prickly, to create a bit of tension and excitement. Even something round and large among a collection of smaller round things helps break the monotony a little. An apple, especially one with a stem and leaves, placed among a composition of grapes, gooseberries, currants, and blueberries, adds variety of size and color, and its leaves and stem add some contrast in texture, shape, and line.

So, how shall we use contrast to make our hypothetical painting appealing, interesting, exciting? Here are some ideas:

- Cool colors in a warm painting? (With our red rose, red flowers, and red ribbon, something a little cooler in color would certainly offer variety and relief.)
- Straight lines among curved ones? (Rose petals are softly curved, likewise the flow of the leaves and the ribbon.

Choose one of the four intersecting points for the location of your focal area.

A Hypothetical Painting

Let's imagine that we'd like to paint a composition in warm colors, consisting of a red rose, other predominantly red flowers, a vase, a red ribbon, and maybe an ornate figurine. Let's say the rose is to be our main attraction. Where, within the focal areas, shall we place the rose? With all that competing red, how can we ensure that the rose will be the main attraction? We might set the rose apart by making it a larger, more dominating size; surrounding it with complementary green leaves; using stronger value contrasts within the rose; or subduing the intensities of the other red flowers and the red ribbon to prevent the eye from wandering aimlessly.

We could further ensure that the rose will grab attention by arranging lines, shapes, or colors to lead the eye to it. We could take the rose out of the vase and place it slightly apart. An isolated item will draw the eye, particularly if we also set it off with strong value contrasts. We can guide the viewer through our painting by the thoughtful use of the principles of design, which will help us make all the "lots of little decisions" we need to consider.

Thorny, stiff rose stems, if not totally obscured by the other flowers and leaves, would provide some sturdy, straight lines. Otherwise, perhaps our choice of other accompanying flowers, vase, or background treatment could provide the needed contrast.)
- Lines curving in an opposite direction from the dominant lines?
- Bug-eaten flowers or leaves among otherwise perfect ones?
- Busy, precise details or patterns in an otherwise calm painting?
- Lost or softened edges in a sharply focused painting?
- A dark value in a predominantly light painting?
- A complementary color (green leaves) added to a predominantly harmonious color theme (various reds)?
- Contrasting sizes (our large rose among smaller roses and red flowers)?
- Horizontal elements in a vertical theme (a drape across the table or a horizontal figurine)?
- A geometric form (our vase, perhaps) in a composition of irregular, organic shapes?

Rhythm and Repetition
Rhythm and *repetition* keep the viewer's eye moving through the painting. Be cautious about repeating identical shapes, sizes, colors, and intervals. Such repetition can seem static and boring. Three identical flowers in a line, evenly spaced apart, are predictable and unexciting. Change the spacing between them, putting two closer together. Or bring one of the groupings of two closer to the foreground. Or change the sizes. Or tip one flower in a different direction. We will still keep the viewer's eye moving through repetition from one flower to the next in the overall composition, but the trip will be more interesting.

Balance
Balance refers to that combination of elements that creates visual stability in the painting. From birth, we have an innate sense of balance. As a newborn, our perception of impending loss of balance caused a great flailing of arms and legs. Then came the struggle to oppose gravity and balance muscles against one another. As adults, we continue to find a lack of balance distressing, whether it is a physical situation or a visual one. So we want to be sure we create a comfortable balance in our paintings. Too much weight on one side of a painting will make it appear unbalanced. When we place our focal area on the spot we identified earlier, we must balance it with what we do to the other side of the painting. Keep the following tips in mind:

- A small, intense colored area can balance a larger area of subdued color.

- A small area of visual texture or more detail can balance a larger, smoother, less busy area.
- A small area of sharply contrasting value can balance a larger area of mildly contrasting value.
- A small area of warm color can balance a larger area of cool color.
- A small mass near the edge of the painting can balance a larger mass near the center (seesaw).
- A single angular shape can balance a bunch of circles or ovals.
- A small complex shape can balance a larger, simpler shape.

Transition
Transition (sometimes called *gradation*) is that which relates one element to the next, such as the way white on the value scale is related to black by the intervening shades of gray. Transition can be created by the way we use color, value, line, space, texture, and so forth to move the eye through the painting. Imagine a painting made only of colors as they came from the tubes or bottles. The sky would be one shade of blue; the grass, one green; the tree trunks, one brown. With no intermixing, there would be no smooth transition from the tree to the sky or the grass, no transitional color to carry the eye easily from one form to the next. Instead, the jump from

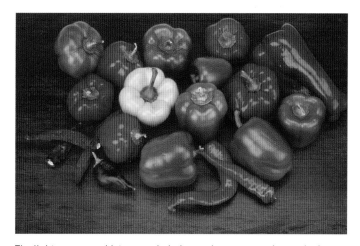

The light pepper amidst so much darkness draws our eye instantly. A second or third yellow pepper added to the group would dilute the impact. If we had hoped to have the purple pepper be the focal point, thinking its unique shape and color, and the fact that we had placed it in front would set it apart from the others, we would have been disappointed. Even a dozen purple peppers could not equal the eye-catching power of the contrasting single yellow pepper.

brown trunk to green grass or blue sky would be sudden and uncontrolled. We may not end up looking where the artist wanted us to look. Whereas mixing a transitional color by adding a little of the blue from the sky into part of the tree trunk and limbs would provide a visual bridge from the tree to the sky. Directing the line of the tree branch to point to or overlap the roof line of a house would provide transition from the line of the tree and carry the eye along from tree to house. Following are some things we can consider to provide transition in our paintings:

- Use color through reflected lights to tie neighboring forms together.
- Use the dark values of shadows to lead the eye from one place to the next.
- Use gradually changing values, colors, lines, shapes, sizes, and spaces to relate one area to the next.
- Bend a branch, curve a drape, fold over a leaf, or angle a prop to lead the eye to the next element or contour.
- Overlap elements to provide transition.

Unity

Unity (sometimes called *harmony*) is that combination or arrangement of all the elements of the painting to make everything appear to belong together. Through clever use of the elements and principles you could even make a lobster and an Easter basket appear to belong together.

For a painting to have unity does not mean that it should be overwhelmed with "sameness." If, in fact, there is too much sameness or equality, then there is no unity or harmony because our attention is equally divided. Variety makes a painting interesting. Variety can be achieved by making adjustments in sizes, values, color, shapes and so on, and still create harmony or unity. Every aspect of the painting must work together and share the load of making the painting a success.

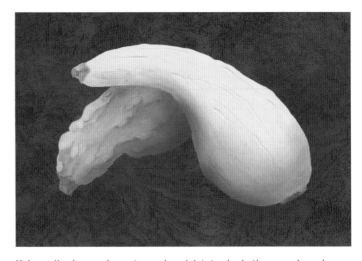

Using yellow's complementary color, violet, to shade the squash anchors the squash to the mottled violet background by providing a transition. Touches of yellow in the background help connect the yellow squash to it. The arrangement of the squashes creates stability in balance; and the warty versus smooth skin provides contrast.

BACKGROUND COLORS

Consider what happens to the different subjects in these sketches with each change of background color. To make it easier for you to compare the effect backgrounds can have, I have kept many of the subject colors fairly identical in each sketch. As such, most of the subjects are not well unified with the backgrounds. Compare what happens, however, when the background color is introduced into the subjects (see the artichokes on the red, dark green, and purple backgrounds). Try to determine what works, what does not, and what you'd do differently. Think of ways you might change the values and intensities of the subjects and/or the backgrounds to more prominently feature or subdue particular subjects.

Unifying Subject and Background

Our backgrounds are most effective when their colors work in conjunction with the subject matter they surround. After you have chosen the color, value, and intensity for the subject matter and background of your painting, you have to make sure that the two work together. There are a number of ways in which you can unify the subject matter of the painting with the background.

- Mix a little of the background color into the colors used for painting the subject. This will also lower the intensity of the subject colors.
- Use the background color to shade or highlight the subject, depending upon the color.

- Let the background color peek through the subject matter. You will notice when you work through the step-by-step lessons that this is a technique I use a lot. Depending upon the hue and value of my background, I may let it help suggest the shading, the highlighting, or the general color of my subject by applying the subject's local coloring thinly over the background.

Just as we nearly lost the radishes on the red, we barely see—at first glance—the mushrooms on the tan. Without the dark contrast inside the caps, and the surrounding radishes, they would really be lost. To preserve the mushrooms, we could change their hue slightly, or change the value that surrounds them. To focus more attention on the artichoke and less on the radishes, we could deepen the shading and details on the artichoke and soften the colors and contrasts of the radishes.

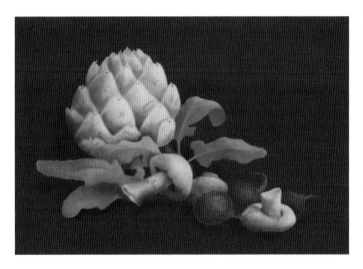

The low-intensity red of the background, because it is the complementary color of green, sets off the greens nicely. The contrast pulls our gaze to the artichoke and the leaves. Ah, but which will we focus on—artichoke or leaves? The size and busy detail of the artichoke help it take center stage. Those curved, pointed petals and all the detail in the scars scream, "Look at me!" The value contrast (light versus dark) pulls our eye from one mushroom to the next. The radishes are melting right into the background. To keep them from disappearing entirely, we could darken the red behind them and/or brighten (change the intensity of) and lighten (change the value of) their hue slightly.

On the light green background, we lose a major part of our composition, but we certainly found the radishes! If we absolutely wanted a green background, would it help to darken its value? You bet! We would regain somewhat the "lost" portion of the composition—the artichoke and the leaves. The strong value contrast of a darker green background would also throw the spotlight on the very light mushrooms.

On this light green background, look what happens when we adjust the hue, value, and intensity of the radishes. They "fit" better with the rest of the subject matter, giving a soft, gentle effect. And, in spite of the fact that I've even added a fifth radish, the radishes don't command attention as they do on the light green background at left.

On the dark green background, the leaves are unobtrusive, focusing attention on the other subjects. The mushrooms first catch our eye, particularly the long-stemmed one, because of the strong value contrast and detail. From there, our eye is pulled upward to the artichoke, lured by the bright, light contrast, and by the upward thrust of the artichoke leaves. Now, perhaps, we notice the radish leaves and follow the downward curves to settle on the radishes. Having touches of red scumbled throughout the background helps balance the red of the radishes, making them not so unique a color.

This violet background seems a little too sweet for these hearty veggies. And there's no unity between the subject and the background, even though I added violet tones in all the items. Could we make a violet background work? Possibly. One way would be to lower both the intensity and the value of the background to create a more earthy tone. Then we'd need to adjust all the colors in the sketch, working more violet into the mixtures. That would help anchor the composition. If we wanted to showcase the mushrooms, we could tint them a warm gold (yellow being the complement of violet). Touches of golden highlights on the artichoke and leaves would help the eye travel through the composition.

SURFACE PREP AND FAUX FINISHES

You can re-create the backgrounds I used in the step-by-step lessons with a few additional supplies. Or you can use the tools and techniques discussed here to create your own backgrounds. The photos on the next three pages illustrate some special backgrounds and faux finishes I used in the lessons.

Brushes for Basecoating

For general basecoating, I use a Loew-Cornell Series 7550 ¾- or 1-inch flat brush. Although the brushes are expensive, they are worth the investment over time. Well cared for, they will last for years, and will outperform dozens of foam brushes, facilitating the application of smooth basecoats and finishes and crisp, sharp edges for trimming. For special effects such as scumbling (stroking several colors in an overlapping crisscross fashion), I use the 1-inch brush of that series. To paint streaks, I like a 1-inch chip brush.

Several of the backgrounds call for the application of thin washes of color. When applying washes for marbleizing or other texturizing techniques, you may find it helpful to work with extender or retarding mediums and water mixed in your paints. This will give you more working time before the paint starts to set up. And of course, the larger the brush you use, the more quickly you will be able to work. When you do add mediums to your paint, be sure to dry the wash thoroughly with a hair dryer before proceeding to the next step. Otherwise, the thinned layer may lift off when wetted with the next paint application.

Apply thinned paint with a stiff-bristled brush to create a streaky bakground.

Scumble strokes in a crisscross fashion to create a broken-color background.

Create a crackled, aged appearance with a weathered wood finishing product.

Using a Mini Paint Roller

For painting some backgrounds on large surfaces, a 2-inch mini paint roller is convenient. To paint a gradated wash over a solid background color, first apply a thin layer of water plus painting medium with the roller. Then, with the water and medium remaining in the roller, pick up the desired color and roll it on the area you wish to be the darkest value. As you work away from the starting point, you will have less and less paint in the roller and the color will be fainter.

To achieve a more opaque coverage with gradated colors, begin with the lighter value color. Starting at one end of your painting surface, roll the color on, covering about one fourth to one third of the area. Then doubleload the roller with the light color on one edge and the next color on the other edge. Roll those two on, slightly overlapping the previous application with the light edge of the roller, and working to create a smooth blend. To add another color or value, roll as much of the light value off the roller onto paper towels as you can. Then, again, doubleload the roller, this time with the new color and the one just previously used. Be careful not to pick up the roller from one area of the painting and jump to another area—you'll get a sudden shift of colors or values. Instead, roll from one area to another, letting the colors blend as you go. Consider basecoating the surface first with a color that would enhance the effect you're hoping to create, a color that would help pull together any colors you're going to roll on top of it.

Special Effects

Household sponges, sea sponges, chamois cloth, and crumpled plastic wrap pressed into wet paint to lift it off, or filled with paint to press it onto a surface, result in some interesting effects. Sponges and chamois cloth leave a soft-edged effect, especially when working with thinned paint. Plastic wrap imparts crisper details. Use sponges, chamois cloth, and plastic wrap to create leather-, granite-, and marble-like effects.

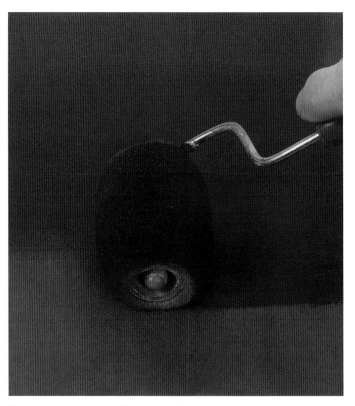

Use a 2-inch roller to easily merge colors into one another, for a gradated background.

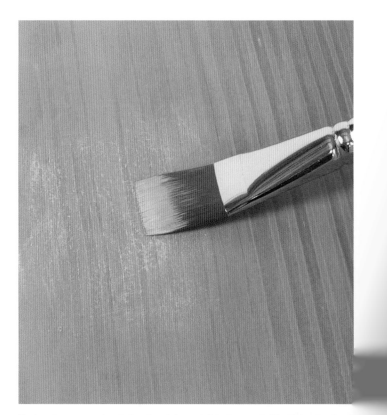

Drybrush across raised streaks of dry paint to leave slight glints of color.

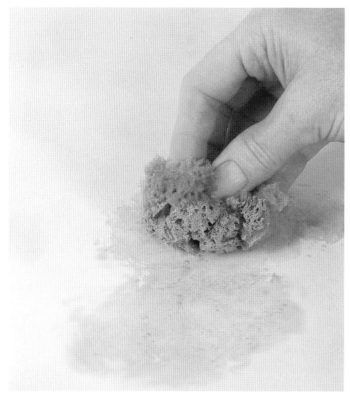

Press crumpled plastic wrap, chamois cloth, or a sponge into wet paint to create a leather-like texture.

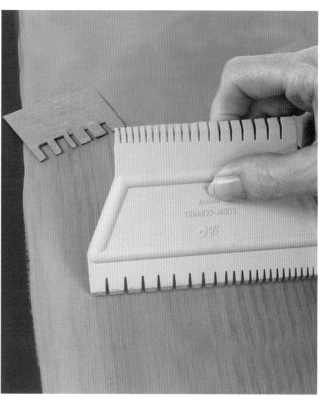

To create a background that resembles wood, streak the paint with a woodgraining comb or a piece of cardboard with "teeth" cut in it.

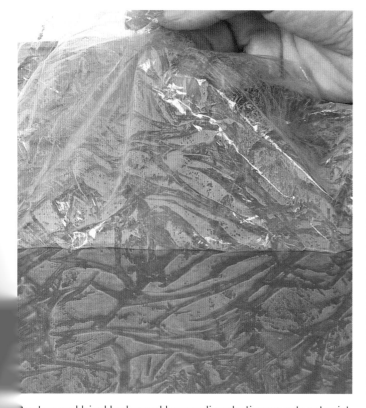

Create a marbleized background by spreading plastic wrap onto wet paint.

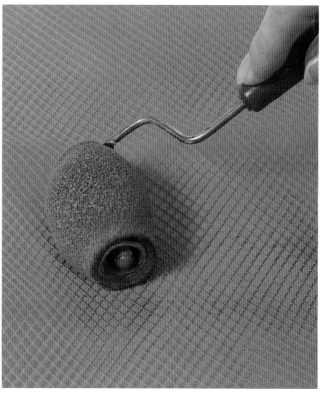

Roll paint across a plastic onion bag for a unique texture.

AMARYLLISES

My collection of amaryllis bulbs, saved from many Christmases past, bloom now each summer in an array of rich, hot colors. This striking, tall flower, with its upward shooting leaves, lends bold strength to a composition.

PALETTE
- Pumpkin
- Naphthol Red
- Forest Green
- Jade Green
- Moon Yellow
- Buttermilk

BRUSHES
- Flats: Nos. 6 and 8
- Liner: No. 1

Hints

1. Use the liner brush to paint the veins in step 2 and the pistil and stamen in step 5. Use the flat brushes for all other steps. Use the brush best fitted for the area being painted.
2. Because this subject is painted on a light background, some of the background sparkles through the undercoat for highlights. Work with watery-thin acrylic paints, building up the dark values slowly in thin layers.
3. Refer to all colors on the lesson page to match and mix colors.

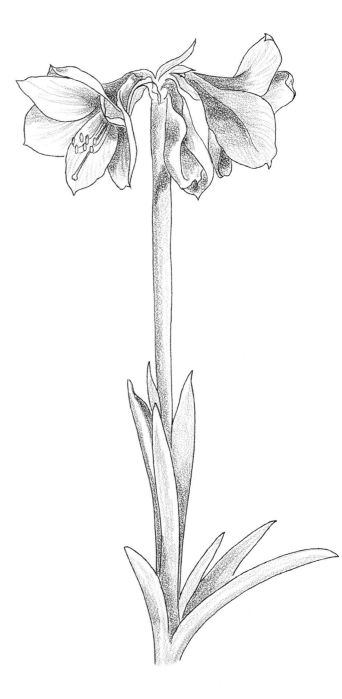

The deep red-orange amaryllis blossoms seem especially brilliant in this split-complementary color scheme.

This is a more harmonious color scheme (analogous) than the one above, which is strongly contrasting.

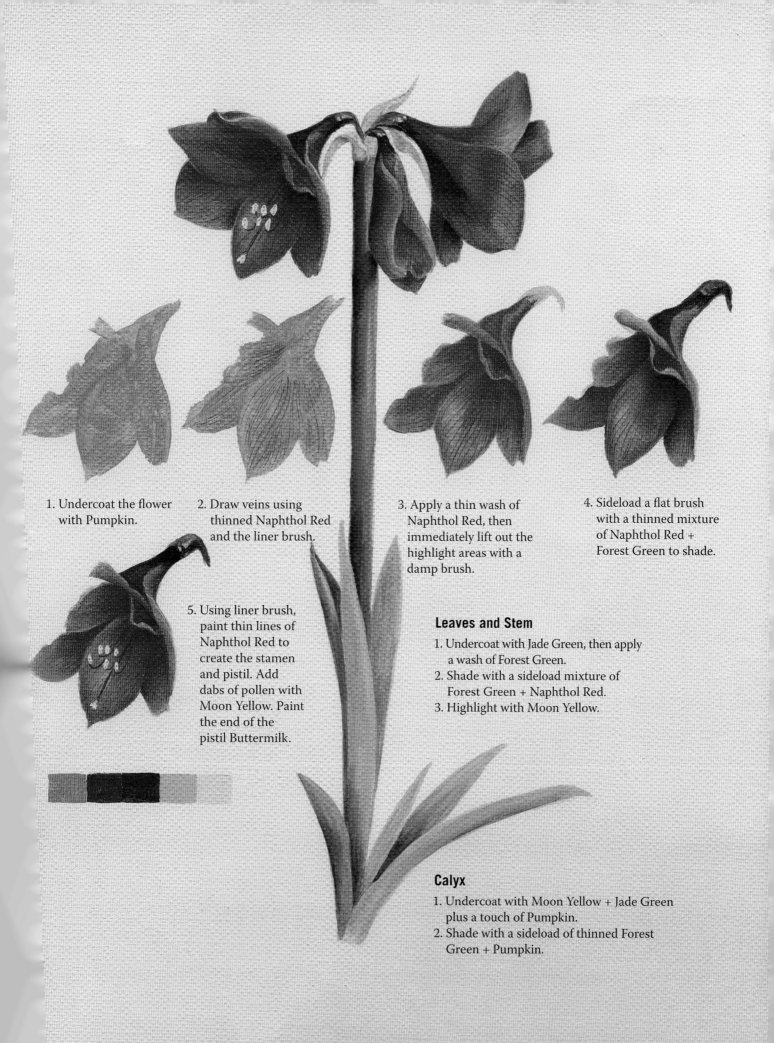

1. Undercoat the flower with Pumpkin.

2. Draw veins using thinned Naphthol Red and the liner brush.

3. Apply a thin wash of Naphthol Red, then immediately lift out the highlight areas with a damp brush.

4. Sideload a flat brush with a thinned mixture of Naphthol Red + Forest Green to shade.

5. Using liner brush, paint thin lines of Naphthol Red to create the stamen and pistil. Add dabs of pollen with Moon Yellow. Paint the end of the pistil Buttermilk.

Leaves and Stem

1. Undercoat with Jade Green, then apply a wash of Forest Green.
2. Shade with a sideload mixture of Forest Green + Naphthol Red.
3. Highlight with Moon Yellow.

Calyx

1. Undercoat with Moon Yellow + Jade Green plus a touch of Pumpkin.
2. Shade with a sideload of thinned Forest Green + Pumpkin.

Amaryllises Reference Photos

The close-up detail photo of the dry, papery calyx also shows how three or four of these large flowers emerge from the top of the sturdy flower stalk. Notice, in the pink-streaked white amaryllis, how the flow of the vein lines suggests the curvature of the petals.

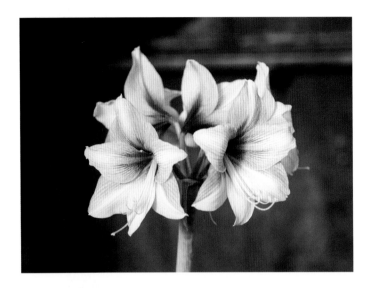

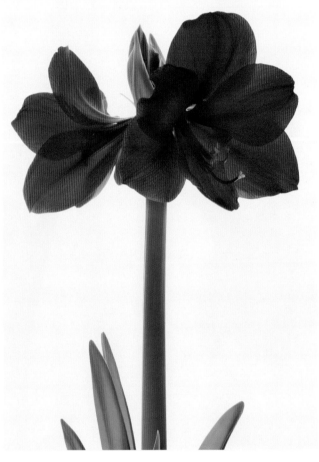

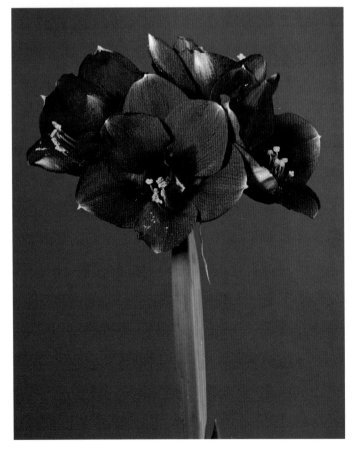

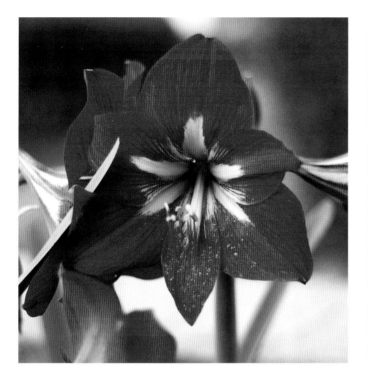
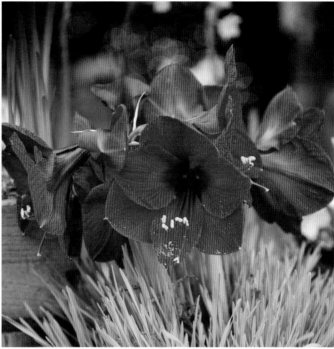
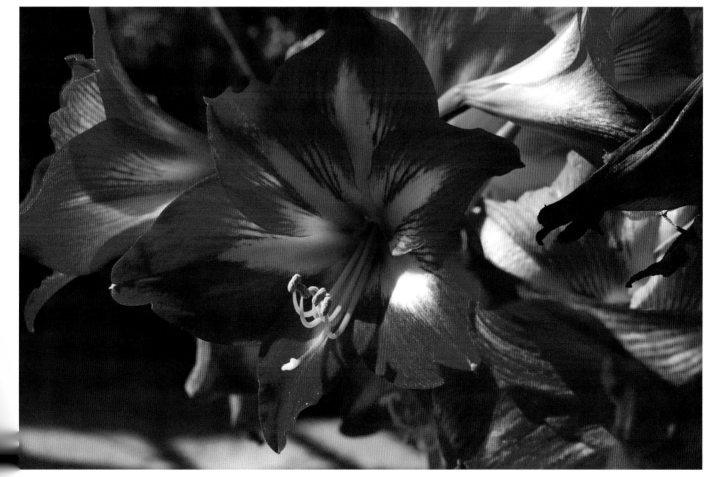

CROCUSES

Crocuses are scattered throughout nearly all my gardens. They're a sign of spring in its beginning, and the hope that winter is behind us. There is a fall blooming variety that tells us that winter is on its way.

PALETTE
- Indian Turquoise
- Cadmium Yellow
- Dioxazine Purple
- Georgia Clay
- Red Violet
- Ultramarine Blue
- Leaf Green
- Black Forest Green
- Titanium White

BRUSHES
- Flats: Nos. 4 and 6
- Round: No. 0

Hints

1. Use the No. 6 flat brush to paint the flowers, the No. 4 flat brush to paint the leaves, and the round brush to paint the leaf veins and the stamen.
2. To paint red-violet crocuses, use the colors suggested for the irises on page 82; for white crocuses, use the white lily colors on page 86.

1. By using the chisel edge or a corner of the flat brush to paint streaks on the flower petals (in step 2) and the white veins in the leaves, you will get a softer, less obtrusive, more natural look than if you use the round brush or a liner brush. If you find the flat brush too difficult to use and are thus using a liner brush, work with very thin paint. Do, however, use the fine-pointed round brush or a liner brush with less watery paint to paint the highlight details in step 5.
2. Refer to all colors on the lesson page to match and mix colors.

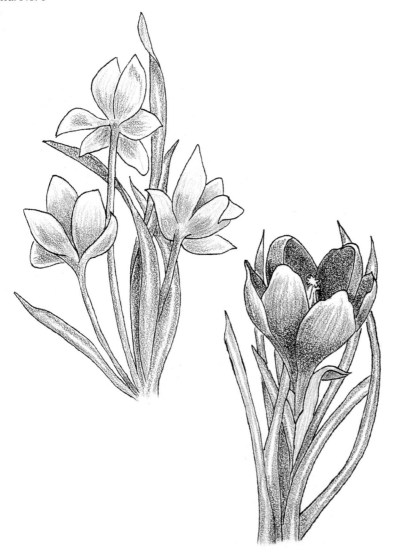

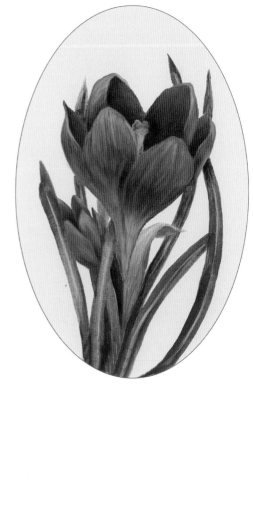

Leaves

1. Undercoat the leaves with Leaf Green.
2. Sideload Black Forest Green to shade the leaves.
3. Thin Titanium White to paint the center vein.

1 2 3

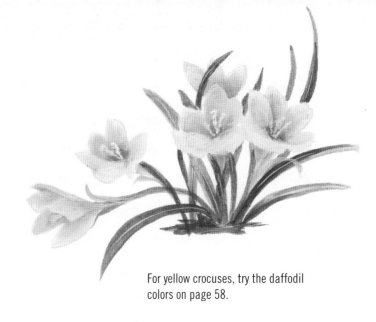

For yellow crocuses, try the daffodil colors on page 58.

Flowers

1. Undercoat the petals with Indian Turquoise and the stamen with Cadmium Yellow.

2. (a) Cover the petals with a thin wash of Dioxazine Purple. (b) While the wash is still wet, streak it with the paint remaining in the corner of the brush. Add a wash of Georgia Clay on the stamen.

3. Shade the petals with a thinned sideload of Red Violet. Add more Georgia Clay to the stamen.

4. Deepen the shading on the petals with a mixture of Red Violet + Ultramarine Blue. Shade the stamen with a mixture of Dioxazine Purple + Georgia Clay.

5. Highlight the top edges of the petals with a mixture of Indian Turquoise + Titanium White. Add pollen dots of Georgia Clay to the stamen.

Calyx

Paint the papery calyx with a light value mixture of Titanium White + Leaf Green + Cadmium Yellow + Dioxazine Purple. Vary this mixture to create a darker value for the shading.

Crocuses Reference Photos

Study the shadows cast by the petals and stamen in the photo below. Try to determine why each shadow is shaped the way it is, and how the shadow shape helps us know the shape of the petal on which it is cast.

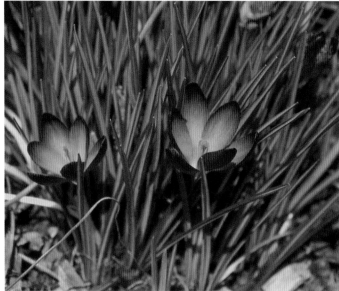

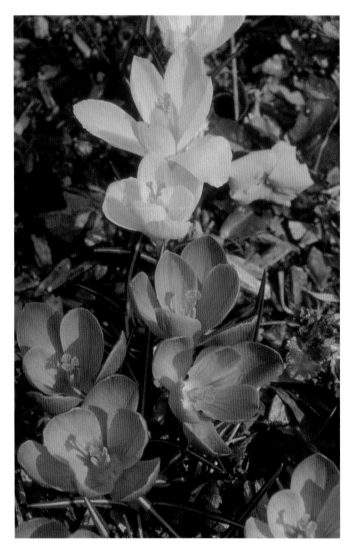

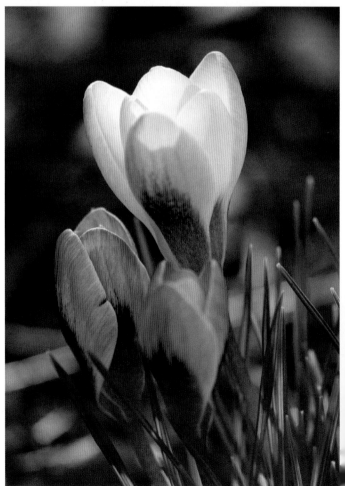

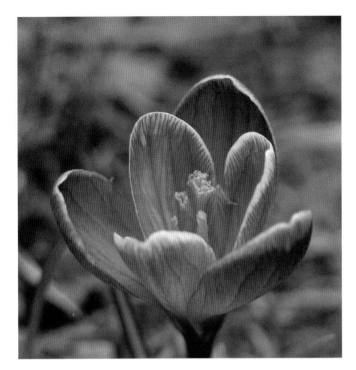
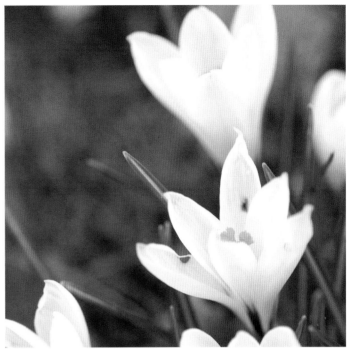
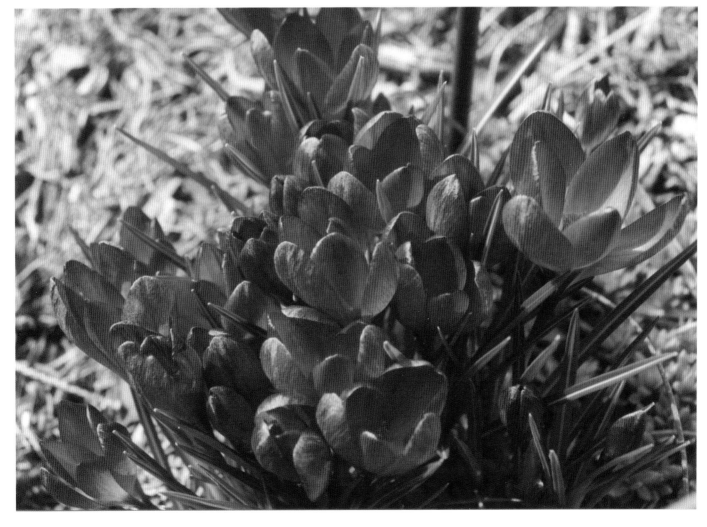

DAFFODILS

Daffodils run rampant in our yard. They are a welcome sign of spring. The delicate ruffled petals show warmth of the seasonal appearance. They disappear with the approach of the summer glow.

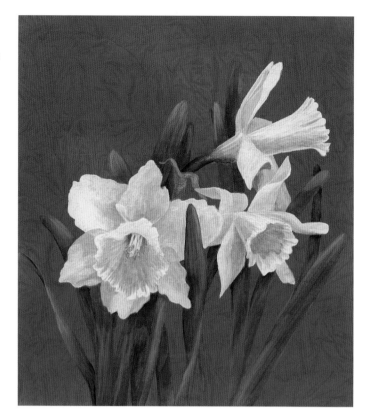

PALETTE
- Titanium White
- Yellow Light
- Light Avocado
- French Grey Blue
- Cadmium Yellow
- True Ochre
- Evergreen

BRUSHES
- Flats: Nos. 6 and 10
- Liner: No. 2

Hints

1. Use the No. 6 flat brush for all petal and leaf steps except for the wash in step 2. Use the No. 10 flat brush for that. Use the liner brush to paint the pistil, stamen, and pollen.

2. On areas that you wish to appear lighter, apply heavier undercoat paint.

3. Refer to all colors on the lesson page to match and mix colors.

4. To paint the "trumpet" in step 1, hold the sideloaded brush so the paint side touches the edge of the trumpet. Slide lightly on the brush's chisel edge into the throat of the trumpet to deposit heavy ridges of paint separated by strips of thin paint. Be sure to follow the contours of the flower.

5. If any shading or accent colors are too strong after completing the daffodils, "merge" them into the daffodil with additional washes of Cadmium Yellow or Yellow Light.

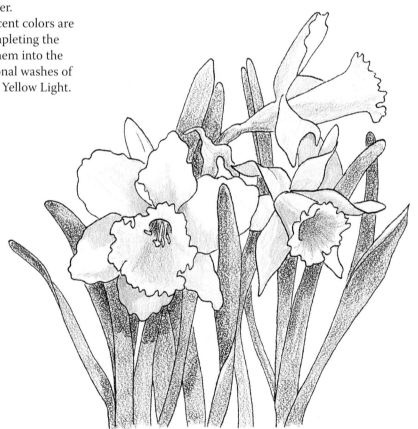

1. Undercoat the daffodil with Titanium White to create texture. Refer to hint 4.

2. Apply a thin wash of Yellow Light.

3. Sideload with Light Avocado + Yellow Light to shade the inside of the trumpet. Deepen the shading with French Grey Blue. Then, shade the petals with French Grey Blue + Titanium White.

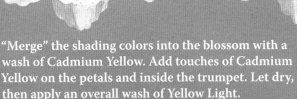

5. Sideload the flat brush with True Ochre and slide it back and forth on its chisel edge inside the trumpet to shade with streaks. Add random touches of True Ochre to the petals where needed for definition.

4. "Merge" the shading colors into the blossom with a wash of Cadmium Yellow. Add touches of Cadmium Yellow on the petals and inside the trumpet. Let dry, then apply an overall wash of Yellow Light.

Leaves

Undercoat the leaves with Light Avocado. Shade them with streaks of Evergreen, then add some highlights with streaks of thinned Titanium White + Light Avocado.

Pistils and Stamens

To paint narrow lines in the flower's center as in the finished flower, mix together Titanium White + Yellow Light. Let dry; apply a thin wash of Cadmium Yellow over the base of the lines. Stipple on pollen dots with True Ochre.

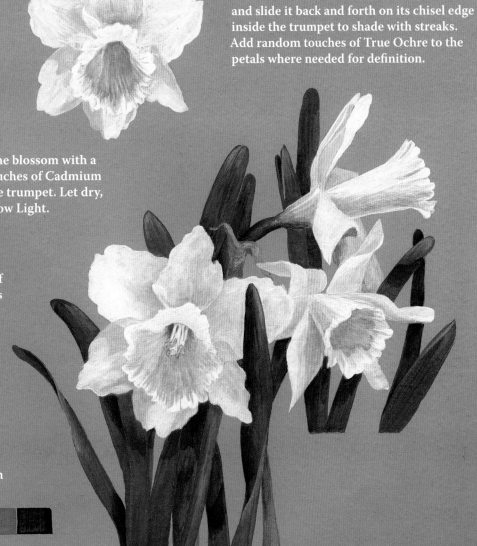

Daffodils Reference Photos

Use some of the photos showing different perspectives (opposite page) to help you design an arrangement of daffodils. Observe what a difference the location of the light source makes by comparing the flowers lit from above with those lit from behind.

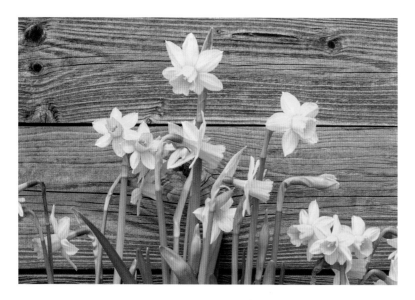

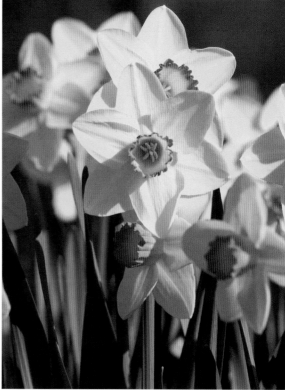

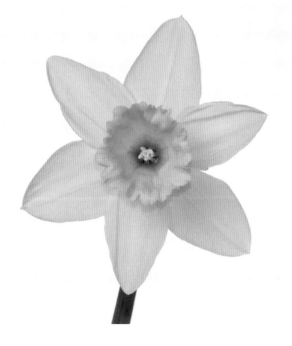

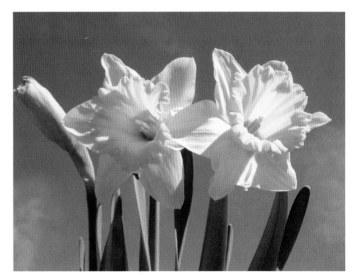

DAISIES

Paint other daisy-like flowers such as sunflowers, rudbeckia (black-eyed Susans), and echinacea (coneflowers) by applying a wash of yellow or pink over the white daisy petals. Add darker values to shade. Stipple centers with brownish yellow to brownish orange. The leaves may vary in shape from lobed; to toothed; to smooth.

PALETTE

- French Grey Blue
- Dove Grey
- Titanium White
- Dioxazine Purple
- Blue Haze*
- Antique Gold
- Cadmium Yellow
- Black Forest Green

*Mix using two parts Teal Green + one part Wedgewood Blue + one part Graphite.

BRUSHES

- Flat: No. 6
- Round: No. 4
- Scruffy brush or deerfoot brush (for stippling centers)

Hints

1. Use the round brush for the flower petals, the flat brush for the leaves, and a scruffy brush for stippling the flower centers.
2. Refer to all colors on the lesson page to match and mix colors.
3. The flower centers will require repeated steps to build up color on a dark background. If you choose a lighter value background for the daisies, basecoat the flower centers with a brownish mixture of Cadmium Yellow + Dioxazine Purple to help suggest depth.
4. In step 3, use a separate brush (a flat or round will do) and clean water to moisten the base and tips of three or four petals at a time. Immediately apply the paint strokes as illustrated, beginning and ending a little within the strokes applied in steps 1 and 2. Let these shorter strokes bleed into the moisture to soften their beginnings and endings.
5. Keep the leaves understated to direct the focus to the flowers. Brush on the green mixtures loosely and thinly, applying the darkest values near the flowers.

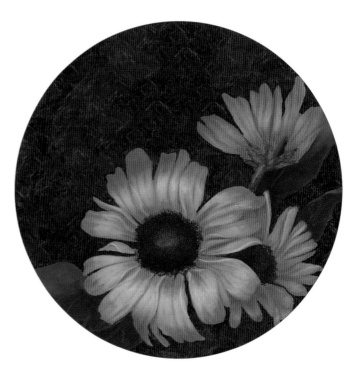

Change your daisies to any color by applying a color wash after completing step 5.

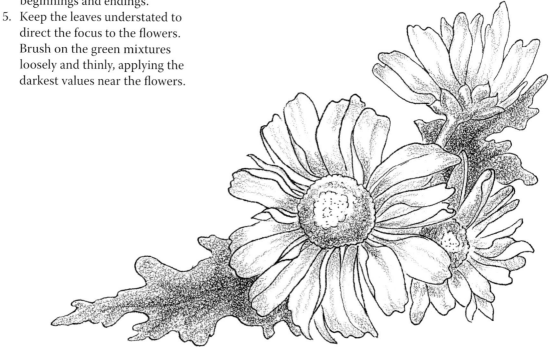

1. Undercoat the petals with thinned French Grey Blue. Paint the centers after completing the petals. For the leaves, use Dioxazine Purple, Blue Haze, Antique Gold, Cadmium Yellow, and Black Forest Green to create a variety of greens.

2. Brush mix French Grey Blue with a little Dove Grey and water. Paint thin strokes on top of the undercoat. Allow some areas of the undercoat to show through.

3. Apply highlight strokes of thinned Dove Grey, a little shorter than the strokes in step 2.

4. Repeat step 3 using Titanium White. Build up the highlight area with many thin lines blurred together. Accent some of the petal edges with full-strength Titanium White.

5. Shade the base of the petals with a thinned mixture of French Grey Blue + Dioxazine Purple. For deeper shading use Dioxazine Purple + Blue Haze

1 2 3 4

Centers
(Refer to instructions below.)

Centers

(Refer to illustrations above.)

Stipple the flower center with Antique Gold + Blue Haze. Stipple Blue Haze + Cadmium Yellow in the middle.

1. Stipple Antique Gold over the entire center.
2. Stipple Cadmium Yellow in the middle.
3. Stipple Titanium White + Cadmium Yellow to highlight.

Daisies Reference Photos

Notice in the photos that all the circles are the same width, but as the perspective changes, the circles (likewise the daisies and the daisy centers) become flatter, more oval shaped. Practice making such mental comparisons whenever you study photographs or actual subject matter.

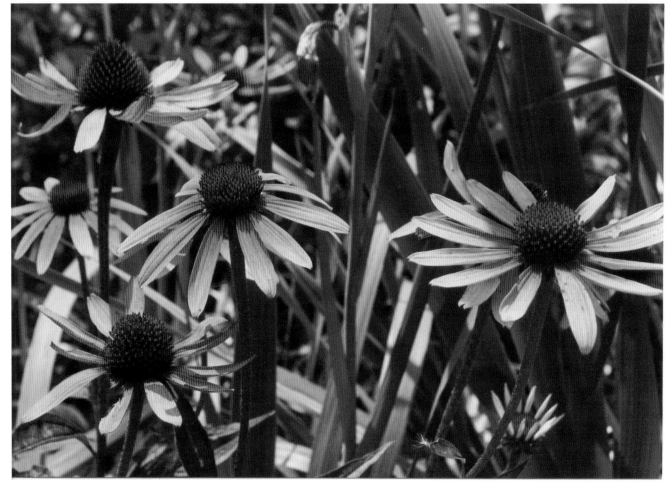

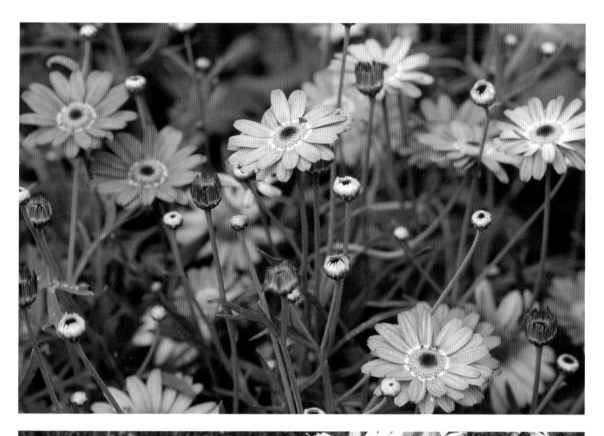

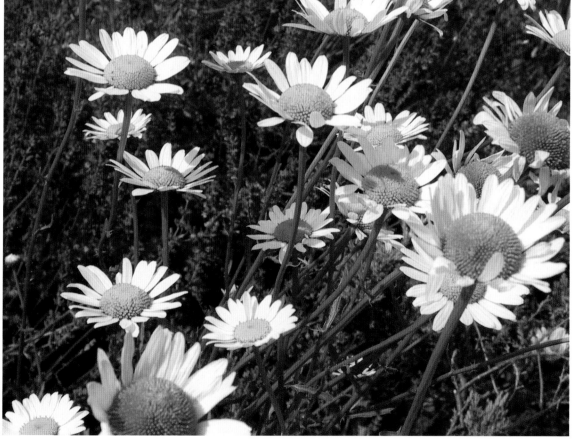

GARDENIAS

When I was young, a gardenia bush grew outside my bedroom window. I loved its intoxicating fragrances. Then, when my husband-to-be, Lynn, and I were married, I carried a single gardenia blossom. It is still my favorite flower; and now, many years later, he is still and always will be my best beau.

PALETTE
- Olive Green
- Mint Julep Green
- Light Buttermilk
- Antique White
- Yellow Ochre
- Wild Orchid
- Plantation Pine
- Hauser Dark Green
- Hauser Light Green
- Raw Sienna
- Buttermilk
- Titanium White

BRUSHES
- Flats: Nos. 2, 4, and 6
- Liner: No. 1

Hints

1. Use the largest flat brush you can comfortably handle for each step. Use the liner brush to paint the "bug bites."
2. To work with the accompanying pattern, transfer only the outlines of the leaves and the overall outline of the gardenia shape. Then after undercoating, transfer or draw in the individual petals.
3. For more hints on painting lateral veins in the leaves with sideloaded V shapes, see the pansies worksheet, page 102.
4. When you first place the shadings in the flower petals, they may appear a little strong. Don't worry. A final unifying color wash will make them a natural part of the flower. Repeat thin wash layers as needed to pull the colors together, making sure the previous layer is completely dry.
5. Refer to all colors on the lesson page to match and mix colors.

If the combination of white flowers on a white background on the worksheet doesn't excite you, here are two other possibilities.

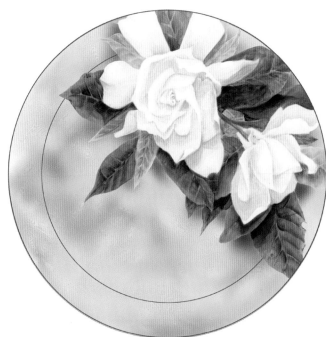

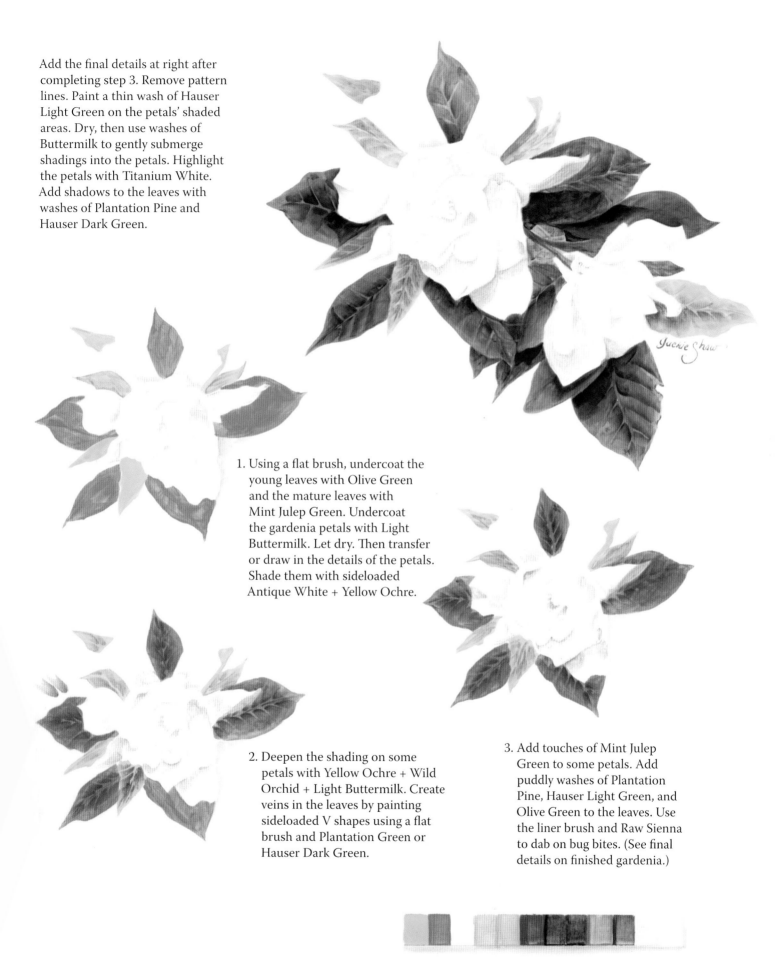

Add the final details at right after completing step 3. Remove pattern lines. Paint a thin wash of Hauser Light Green on the petals' shaded areas. Dry, then use washes of Buttermilk to gently submerge shadings into the petals. Highlight the petals with Titanium White. Add shadows to the leaves with washes of Plantation Pine and Hauser Dark Green.

1. Using a flat brush, undercoat the young leaves with Olive Green and the mature leaves with Mint Julep Green. Undercoat the gardenia petals with Light Buttermilk. Let dry. Then transfer or draw in the details of the petals. Shade them with sideloaded Antique White + Yellow Ochre.

2. Deepen the shading on some petals with Yellow Ochre + Wild Orchid + Light Buttermilk. Create veins in the leaves by painting sideloaded V shapes using a flat brush and Plantation Green or Hauser Dark Green.

3. Add touches of Mint Julep Green to some petals. Add puddly washes of Plantation Pine, Hauser Light Green, and Olive Green to the leaves. Use the liner brush and Raw Sienna to dab on bug bites. (See final details on finished gardenia.)

Gardenias Reference Photos

Compare the strong, shiny, multiple highlights on the crisp gardenia leaves with the subtle, diffused highlights on more limp leaves. Being aware of, and painting, such differences helps add variety to your paintings.

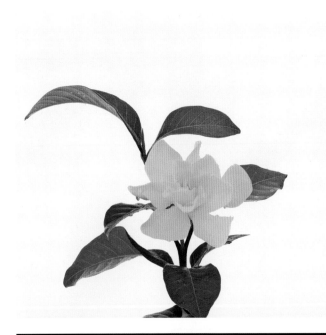
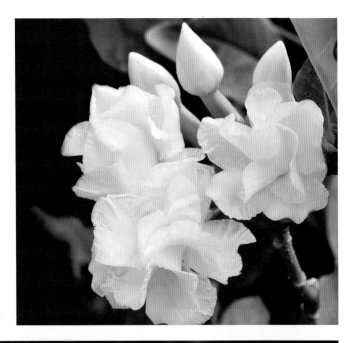
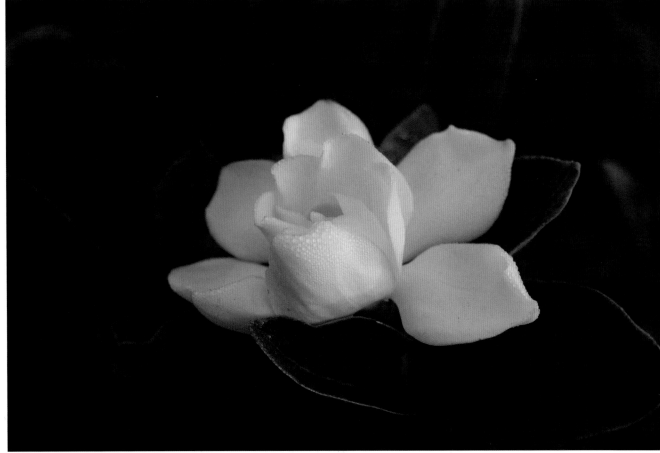

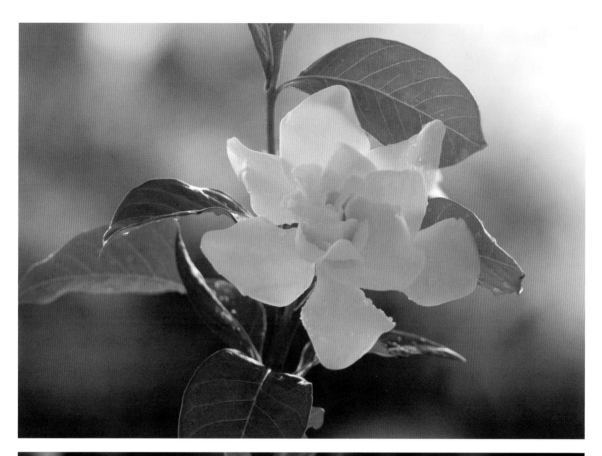

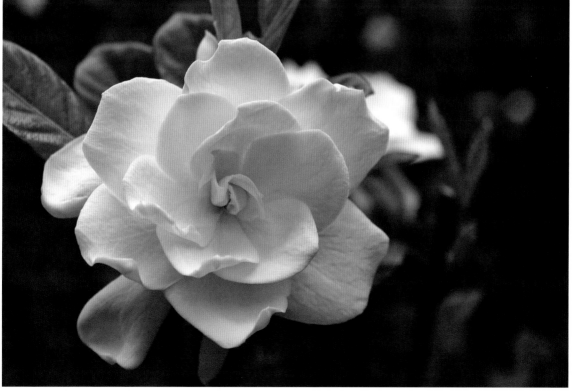

GERANIUMS

My oldest geranium stands more than four feet tall, in spite of consistent pruning. After near total neglect all winter, it seems only too happy to bloom vigorously all summer, much to our delight.

PALETTE
· Coral Blush
· Terra Coral
· Light Buttermilk
· Naphthol Red
· Cadmium Yellow
· Olive Green
· Hauser Medium Green
· Hauser Light Green

BRUSHES
· Flats: Nos. 2, 6, and 8
· Liner: No. 10/0

Hints

1. Use the No. 6 flat brush to undercoat, shade, and highlight all flower petals, except the tiny, turned petals. For these, use the No. 2 flat brush. Use the No. 8 flat brush to undercoat the leaves and to apply the wash in step 7. Use the No. 2 flat brush to paint the spaces between the veins in step 6.

2. To paint pink geraniums, use the colors suggested for hibiscuses or morning glories (pages 78 and 98). To paint red geraniums, use the colors suggested for poinsettias (page 106).

3. Refer to all colors on the lesson page to match and mix colors.

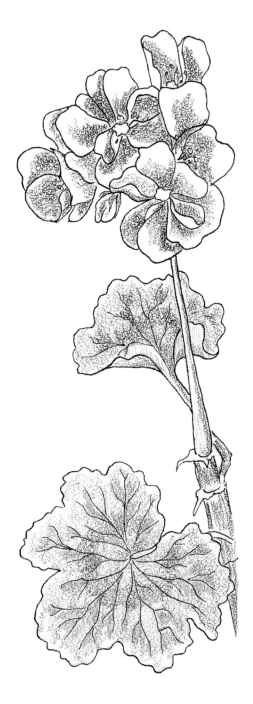

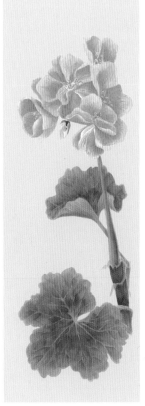

Experiment by substituting background and flower colors for the ones suggested on the worksheet.

1. (a) Undercoat the blossom with Coral Blush. (b) Shade the petals with a sideload of Terra Coral.

3. Use the liner brush and thinned Naphthol Red to paint the veins, following the contours of the petals.

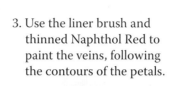

a

 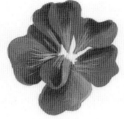 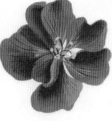

b

2. Highlight the petals with a sideload of Light Buttermilk. Use the chisel edge of the brush and Light Buttermilk to paint streaks from the base of the petals.

4. Deepen the shading with a sideload of Naphthol Red on a flat brush. Using the same color, paint the stamen with the liner brush. Add dots of pollen with Cadmium Yellow.

 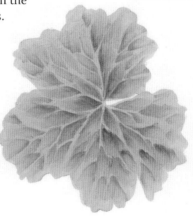

5. Undercoat a leaf with Olive Green. Dry. Then sketch in vein lines with a pencil or chalk pencil.

6. Paint the triangular spaces between the veins with a sideload of Hauser Medium Green, keeping the side of the brush with color facing the leaf center. Let dry, then erase the drawn lines.

8. Sideload a flat brush with a thinned mixture of Terra Coral + Hauser Medium Green. Paint the "stripe" around the center of the leaf. Use the liner brush to add Olive Green.

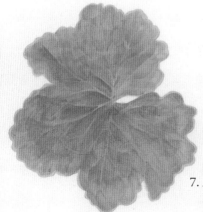

7. Apply a wash of thinned Hauser Light Green to the entire leaf using short, choppy strokes. Finish the leaf by adding the details (referring to finished geranium).

Geraniums Reference Photos

Watching the many little geranium buds burst open from their cluster at the end of outward reaching stems is like watching a fireworks display in very slow motion.

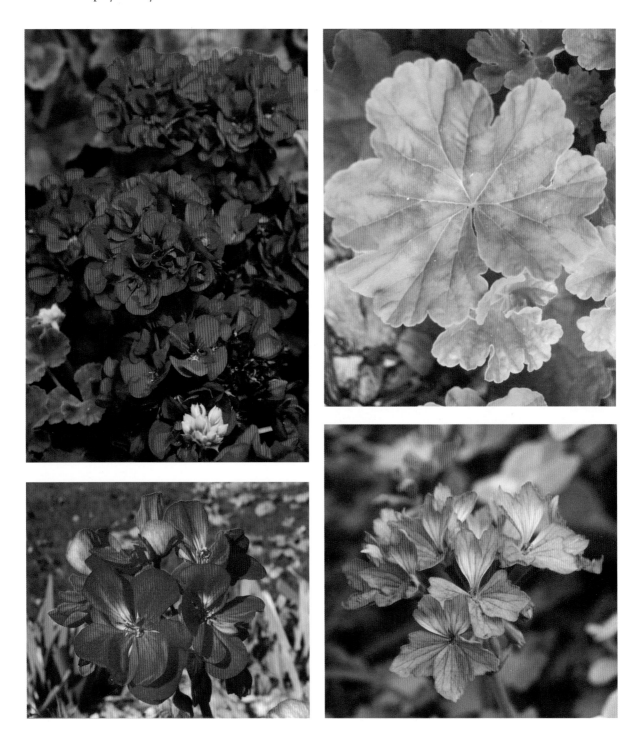

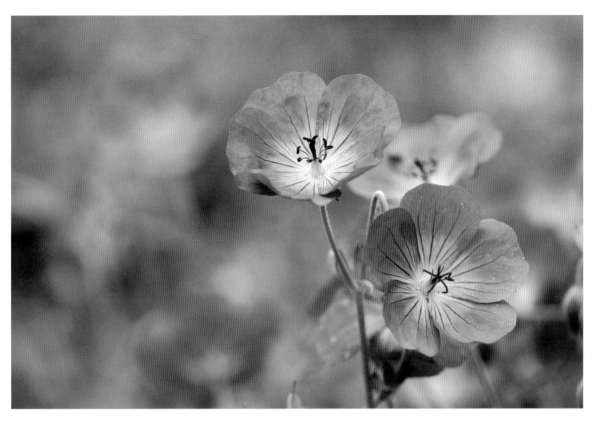

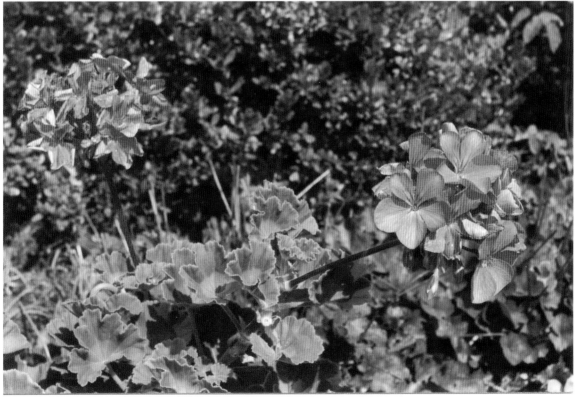

GRAPE HYACINTHS

Like daffodils, grape hyacinths are easy to naturalize in the yard. I use them to embellish the stone borders around my thirty-some gardens. So I seem to be forever digging up little new ones, which have escaped the boundaries, and nestling them back where they belong.

PALETTE
- Titanium White
- Purple Pizzazz
- Dioxazine Purple
- Blue Violet
- Country Blue
- Black Plum
- Foliage Green
- Moon Yellow
- Leaf Green

BRUSHES
- Flat: No. 2
- Round: No. 2
- Liner: No. 2
- 2″ foam roller brush

Hints

1. Use the round brush to undercoat the flowers and to paint the leaves. Use the flat brush to apply washes, shading, and drybrushing. Paint details with the liner brush.

2. Undercoat the grape hyacinths with a well-loaded round brush to create textured ridges in their petals. The ridges will stand out above the succeeding layers of wash.

3. Grape hyacinth flowers open from the bottom of the cluster upward. When the very lowest blossoms have started to shrivel closed, the ones just above them will have the white fringed opening. Farther up the cluster the blossoms will still be closed and egg-shaped. And if you look closely, you may see a star-like shape on the tip where the six petals will pull slightly apart to open, creating the white fringe. Refer to the separate illustrated step for painting these unopened blossoms.

4. Notice that the higher the blossoms are on the stalk, the lighter in value they are. For the lightest blossoms, omit steps 3 and 4.

5. Refer to all colors on the lesson page to match and mix colors.

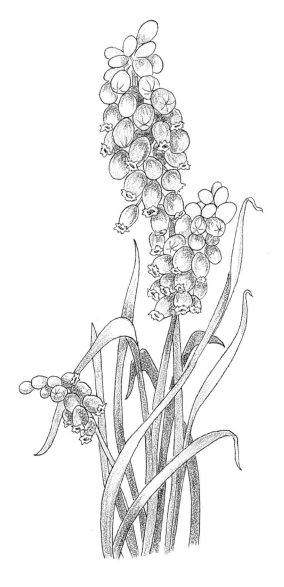

Create a gradated background by using a 2-inch foam roller to blend one background color into another. Basecoat entirely with the main color. Dry; then doubleload the roller to add the deeper color.

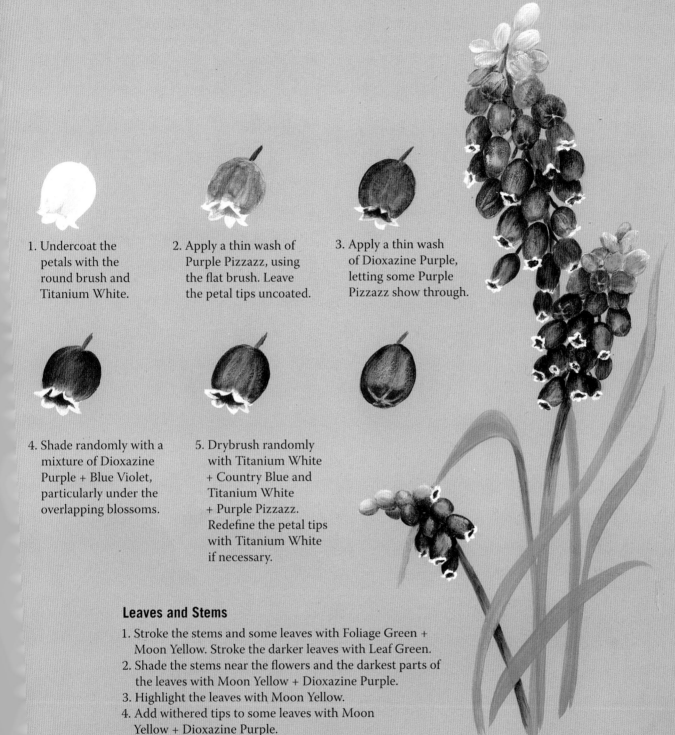

1. Undercoat the petals with the round brush and Titanium White.

2. Apply a thin wash of Purple Pizzazz, using the flat brush. Leave the petal tips uncoated.

3. Apply a thin wash of Dioxazine Purple, letting some Purple Pizzazz show through.

4. Shade randomly with a mixture of Dioxazine Purple + Blue Violet, particularly under the overlapping blossoms.

5. Drybrush randomly with Titanium White + Country Blue and Titanium White + Purple Pizzazz. Redefine the petal tips with Titanium White if necessary.

Leaves and Stems

1. Stroke the stems and some leaves with Foliage Green + Moon Yellow. Stroke the darker leaves with Leaf Green.
2. Shade the stems near the flowers and the darkest parts of the leaves with Moon Yellow + Dioxazine Purple.
3. Highlight the leaves with Moon Yellow.
4. Add withered tips to some leaves with Moon Yellow + Dioxazine Purple.

Unopened Blossoms

Follow the previous steps, then add touches of Black Plum near the closed petal tips.

Grape Hyacinths Reference Photos

Grape hyacinths awake in spring along with the crocus, and seem quite undeterred by a bit of snow. In the photographs, compare the different sensations created by other colors in amongst the grape hyacinths. The bright red adds quite a jolt. The complementary yellow, too, is a lively contrast.

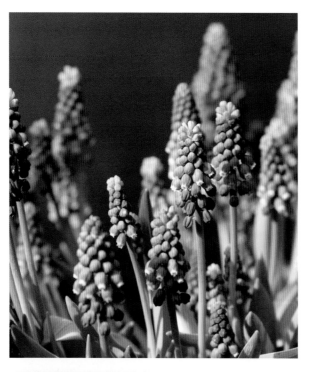
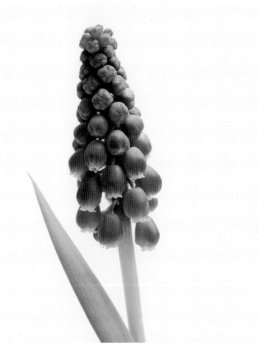

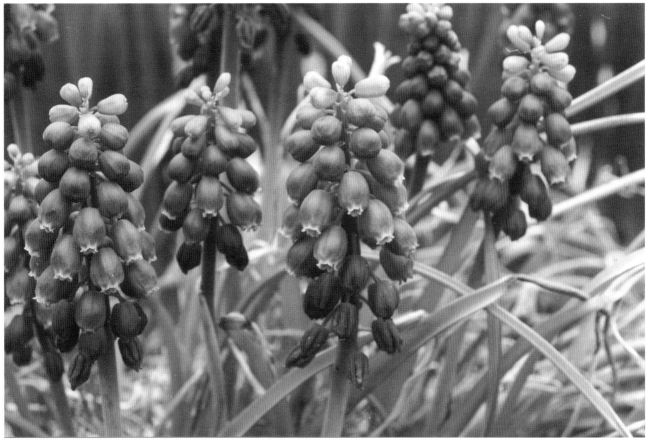

HIBISCUSES

These large flowers can add colorful impact to a painted arrangement without the effort of painting many petals (such as would be required for painting roses or peonies, for example). Painting many ruffles in the petal edges and folds will make the flowers appear soft and delicate.

PALETTE
- Leaf Green
- Hauser Light Green
- Pink Chiffon
- Kelly Green
- Boysenberry Pink
- Terra Coral
- Golden Straw
- French Mauve

BRUSHES
- Flats: Nos. 6, 8, and 12
- Liner: No. 10/0
- Scruffy brush or deerfoot brush (optional)

Hints

1. Use the flat brushes to undercoat, apply washes, sideload, and drybrush highlights. Use the liner brush to paint veins in the leaves and the flower petals.

2. Leaves painted on a mottled green background offer a pleasing way to unify the painting and focus attention on the flowers, provided there is sufficient value contrast between at least some edges of the leaves and the background. In this case, I have texturized the background using a wad of plastic wrap. Sometimes, I let the shapes of the plastic wrap wrinkles suggest the shape of a leaf, and then refine it with darker or lighter values as needed—just enough to make the leaf barely discernable. That creates a leaf that seems to be in the shadows, fleshes out the design when needed, and further connects the subject to the background.

3. Notice in Petals, step 1, how some of the background green peeks faintly through the undercoat. The number of layers of paint you use in step 1 will vary depending upon your background color, your petal color, and how heavily or thickly you apply the paint. Just be sure to leave scattered areas of the background showing through to add subtle hue shifts to your flowers.

4. When adding drybrushed highlights to the flower petals in step 5, hold the brush parallel to the painting and float it lightly across the petals, moving in the direction opposite the vein lines. The underlying ridges of paint will catch glitterings of your highlighted color. (Review "Drybrushing" on page 19.)

5. Refer to all colors on the lesson page to match and mix colors.

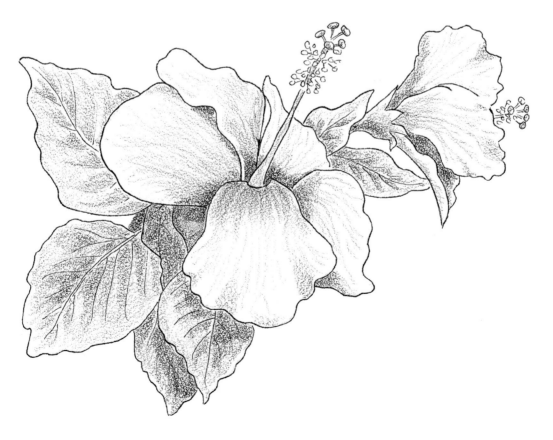

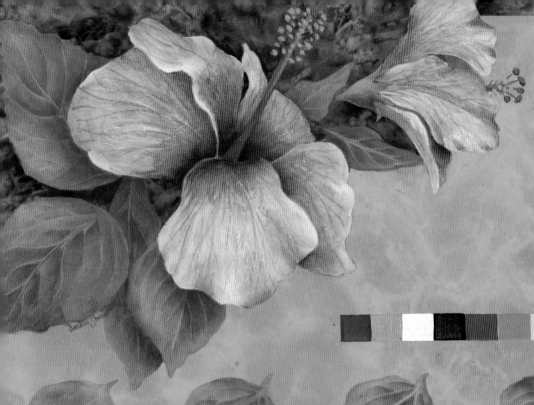

Pistil

1. Undercoat the style with Boysenberry Pink + Terra Coral.
2. Highlight with Pink Chiffon + Terra Coral.
3. Paint the stamen with Boysenberry Pink topped with Terra Coral.
4. Paint the pollen Golden Straw.

Stamen

Style

Leaves

1. Apply a thin, splotchy wash of Leaf Green. While wet, lift out the central vein with a damp brush. Dry.

2. With a chalk pencil, draw vein lines. Then sideload with Leaf Green. With the paint side of the brush toward the chalk line, paint inverted V shapes to create shading between the veins.

3. Paint the veins with the liner brush and Hauser Light Green + Pink Chiffon.

4. Shade the leaf with Leaf Green + Kelly Green sideloaded. Highlight with Pink Chiffon + Hauser Light Green.

5. (See completed design.) Apply a wash of Hauser Light Green over the highlight areas.

Petals

1. Undercoat with three thin layers of Pink Chiffon, building up a streaked texture following the contours of the petals. Dry between each layer. Apply a thin wash of Boysenberry Pink.

3. Paint the veins with the liner brush and thinned Boysenberry Pink. Keep the veins thin and light. If any appear too heavy, quickly blot them to soften.

4. Add random touches of color (French Mauve, Terra Coral, and deeper Boysenberry Pink shading) to suggest ruffles.

5. Drybrush Pink Chiffon across the petals. Then sideload with Pink Chiffon to highlight the petal edges.

6. (See completed design.) Paint the darkest shading accents on the petals with a sideload of Boysenberry Pink + Kelly Green.

Hibiscuses Reference Photos

To paint the different hibiscuses shown in the photos, use the directions for the pink hibiscus in this lesson, substituting color palettes from other lessons as desired.

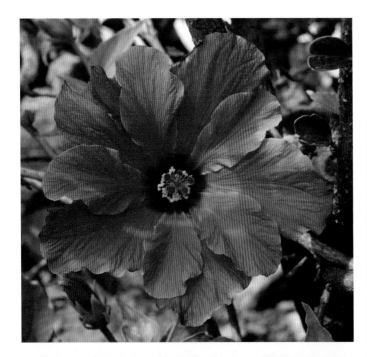

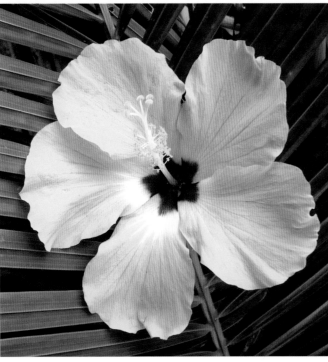

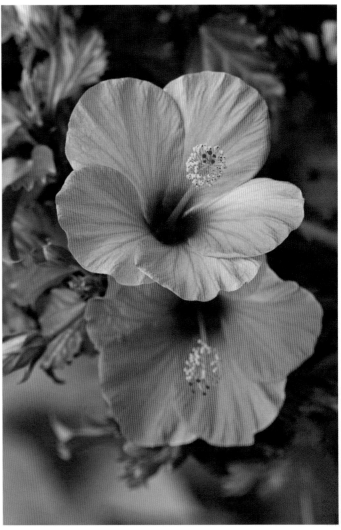

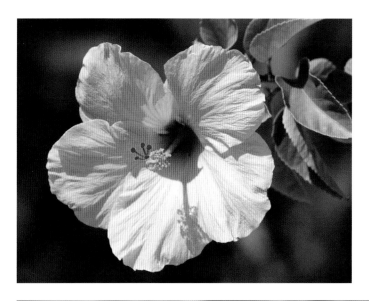

IRISES

The iris, cultivated between 3,000 and 4,000 years ago, was named for the Greek goddess of the rainbow, Iris. A dear neighbor, now deceased, started me collecting irises, which truly run the gamut of colors in the rainbow (and then some!). I have to restrain myself from stopping and begging to exchange rhizomes when driving past a planting of irises in colors I don't have.

PALETTE
- Buttermilk
- Black Plum
- Red Violet
- Primary Yellow
- Royal Purple
- Cranberry Wine
- Sea Aqua
- Kelly Green
- Black Forest Green

BRUSHES
- Flats: Nos. 6 and 8
- Liner: No. 10/0

Hints
1. Use the largest flat brush you can handle for all steps except to paint the veins in the flowers. Use the liner brush for these.
2. When applying washes, make them puddly so they dry with a mottled appearance. This will give the flower petals a more varied, ruffly, and delicate look.
3. Refer to all colors on the lesson page to match and mix colors.

Violet, blue, and green make an analogous color scheme—in this case, a rather lively one.

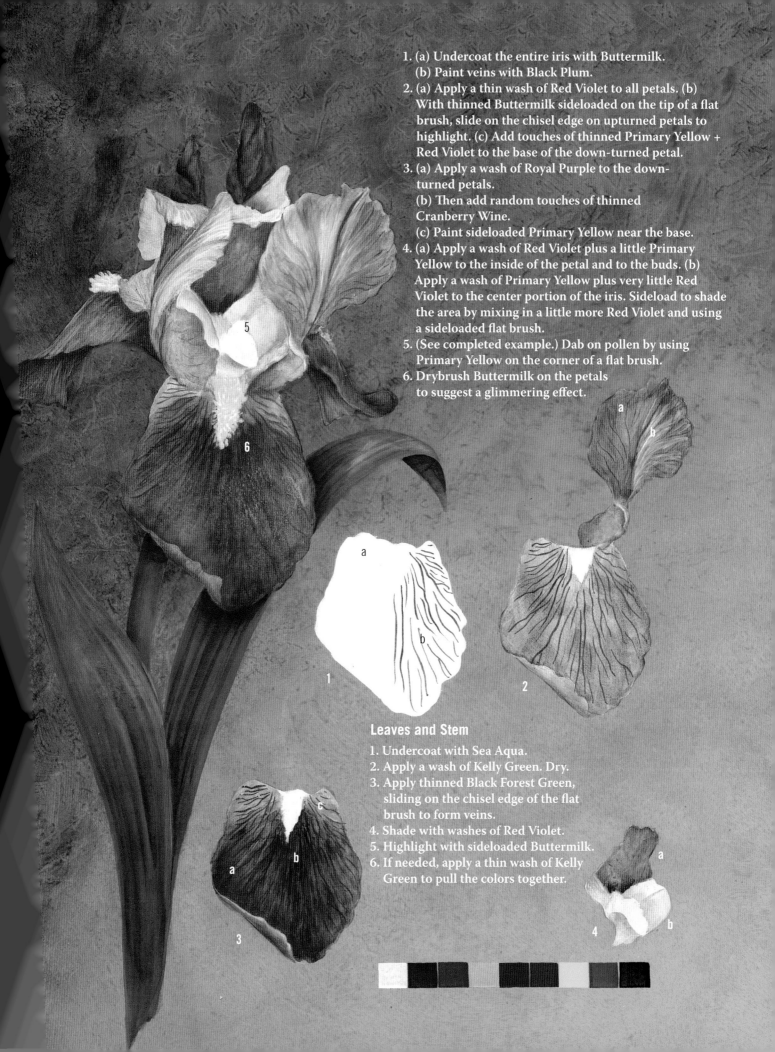

1. (a) Undercoat the entire iris with Buttermilk.
 (b) Paint veins with Black Plum.
2. (a) Apply a thin wash of Red Violet to all petals. (b) With thinned Buttermilk sideloaded on the tip of a flat brush, slide on the chisel edge on upturned petals to highlight. (c) Add touches of thinned Primary Yellow + Red Violet to the base of the down-turned petal.
3. (a) Apply a wash of Royal Purple to the down-turned petals.
 (b) Then add random touches of thinned Cranberry Wine.
 (c) Paint sideloaded Primary Yellow near the base.
4. (a) Apply a wash of Red Violet plus a little Primary Yellow to the inside of the petal and to the buds. (b) Apply a wash of Primary Yellow plus very little Red Violet to the center portion of the iris. Sideload to shade the area by mixing in a little more Red Violet and using a sideloaded flat brush.
5. (See completed example.) Dab on pollen by using Primary Yellow on the corner of a flat brush.
6. Drybrush Buttermilk on the petals to suggest a glimmering effect.

Leaves and Stem

1. Undercoat with Sea Aqua.
2. Apply a wash of Kelly Green. Dry.
3. Apply thinned Black Forest Green, sliding on the chisel edge of the flat brush to form veins.
4. Shade with washes of Red Violet.
5. Highlight with sideloaded Buttermilk.
6. If needed, apply a thin wash of Kelly Green to pull the colors together.

Irises Reference Photos

Space limitations permit only a small sampling of the wide range of colors of irises. But chances are, if you need a particular color flower to complete a composition, you'll find there exists an iris in—or near—that color.

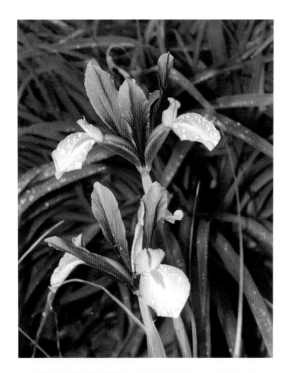

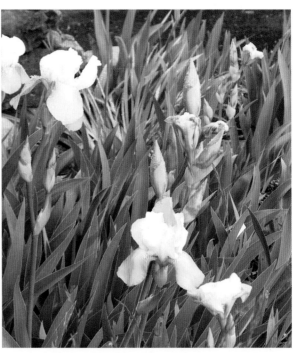

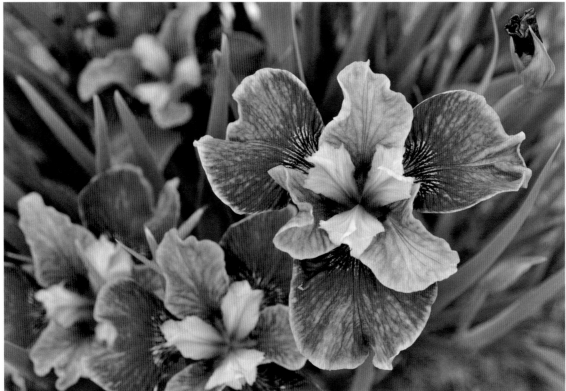

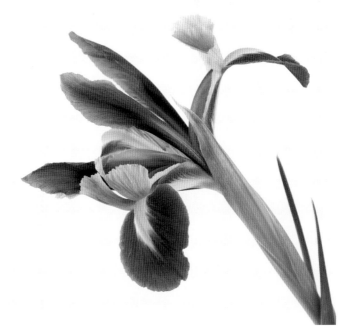

LILIES

There are approximately 100 species and countless hybrids of lilies. I decided to use a white lily for the worksheet because once you paint its light and dark values, you can apply a colored wash to create whatever color lily you like. They come in just about every color. The flowers may face upward, horizontally, or downward; and their petals may be trumpet-shaped (as shown here), bowl-shaped, funnel-shaped, or may curve tightly backward to touch the stem.

Hints

PALETTE
- Buttermilk
- Light Buttermilk
- Charcoal Grey
- French Grey Blue
- Olive Green
- Midnite Green
- Black Forest Green
- Titanium White
- Tangerine
- Burnt Sienna

BRUSHES
- Flats: Nos. 4 and 10
- Liner: No. 1

1. Use the largest flat brush you can handle for all steps except where the liner brush is specifically mentioned.
2. Notice how effective and unobtrusive the veins in the flower petals look when they're created with thin, wet color, moved about on the chisel edge of the No. 10 flat brush. Using the flat brush rather than a liner helps to create subtle shading as well as texture. With the flat brush, we're also less apt to try as hard as we might with the liner to make "just perfect," evenly spaced veins. These flow gently and are then merged slightly into the petals with the wash layer of color.
3. For ideas on background colors for the other lilies, check some of the other lessons to see how the reds, yellows, pinks, and oranges look on various colored backgrounds.
4. Refer to all colors on the lesson page to match and mix colors.

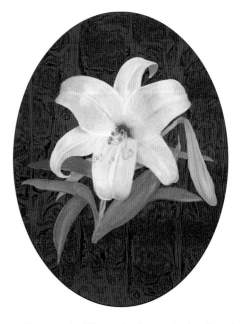

Try not only different background colors but also different lily colors. Notice the different leaves and stamens on the various lilies shown in the photos on pages 88 and 89.

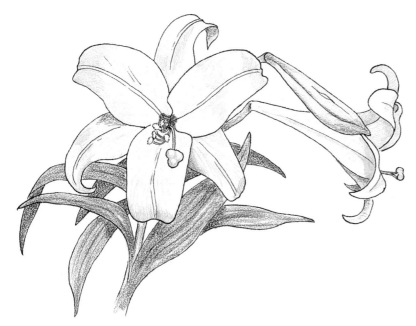

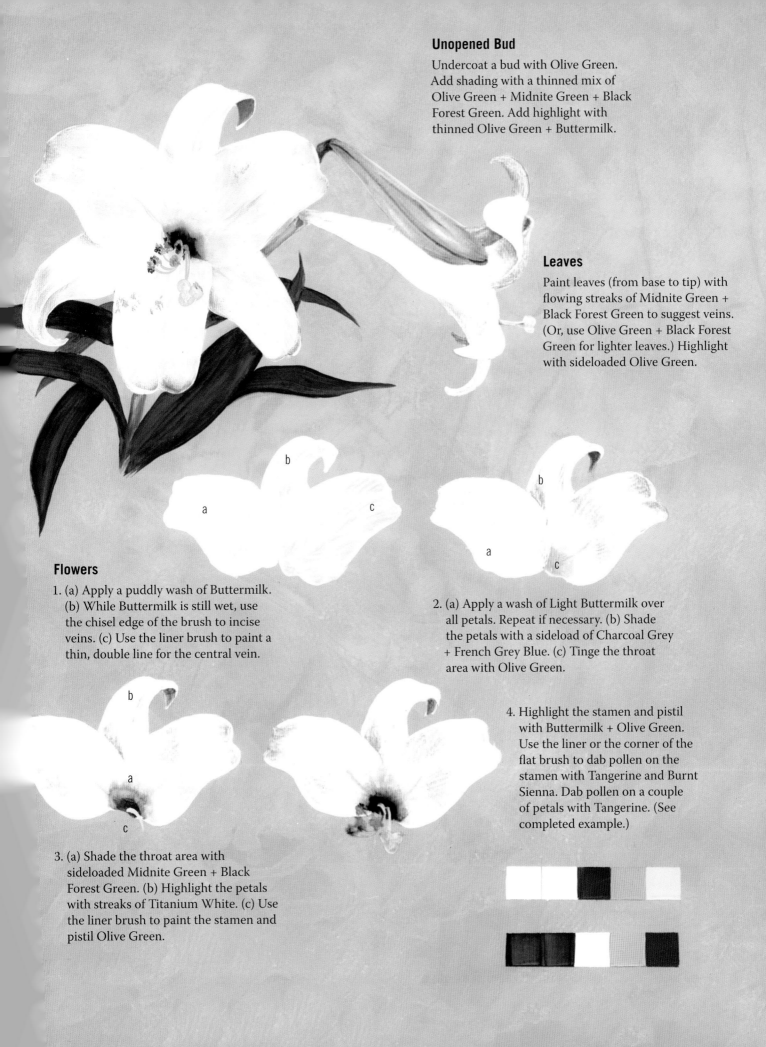

Unopened Bud

Undercoat a bud with Olive Green. Add shading with a thinned mix of Olive Green + Midnite Green + Black Forest Green. Add highlight with thinned Olive Green + Buttermilk.

Leaves

Paint leaves (from base to tip) with flowing streaks of Midnite Green + Black Forest Green to suggest veins. (Or, use Olive Green + Black Forest Green for lighter leaves.) Highlight with sideloaded Olive Green.

Flowers

1. (a) Apply a puddly wash of Buttermilk. (b) While Buttermilk is still wet, use the chisel edge of the brush to incise veins. (c) Use the liner brush to paint a thin, double line for the central vein.

2. (a) Apply a wash of Light Buttermilk over all petals. Repeat if necessary. (b) Shade the petals with a sideload of Charcoal Grey + French Grey Blue. (c) Tinge the throat area with Olive Green.

3. (a) Shade the throat area with sideloaded Midnite Green + Black Forest Green. (b) Highlight the petals with streaks of Titanium White. (c) Use the liner brush to paint the stamen and pistil Olive Green.

4. Highlight the stamen and pistil with Buttermilk + Olive Green. Use the liner or the corner of the flat brush to dab pollen on the stamen with Tangerine and Burnt Sienna. Dab pollen on a couple of petals with Tangerine. (See completed example.)

Lilies Reference Photos

Here are a few varieties of lilies from my garden. To paint them, use the techniques from the worksheet, altering colors as needed. To paint the yellow, soft pink, and light orange lilies, follow the directions through step 2(b). Then apply a wash of your choice of pink, yellow, or light orange. To paint red and deeper orange lilies, use the color Tangerine for the undercoat and wash steps through 2(a). Then, for the red lilies, apply a wash of red, letting it fade into the orange in the throat. Mix a darker value red for the shading in 2(b). For steps 2(c) through step 4, use the photographs to help you select the detailing colors for the throat, stamen, spots, and other markings. Refer to the hibiscus to paint the hot pink lily.

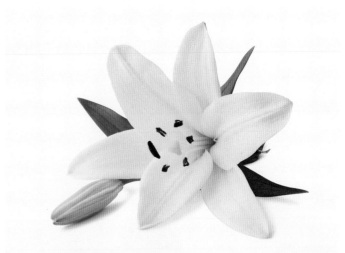

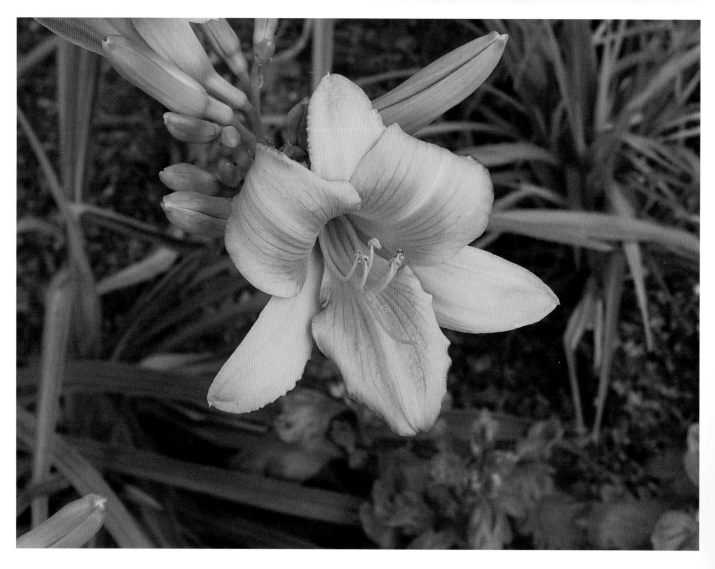

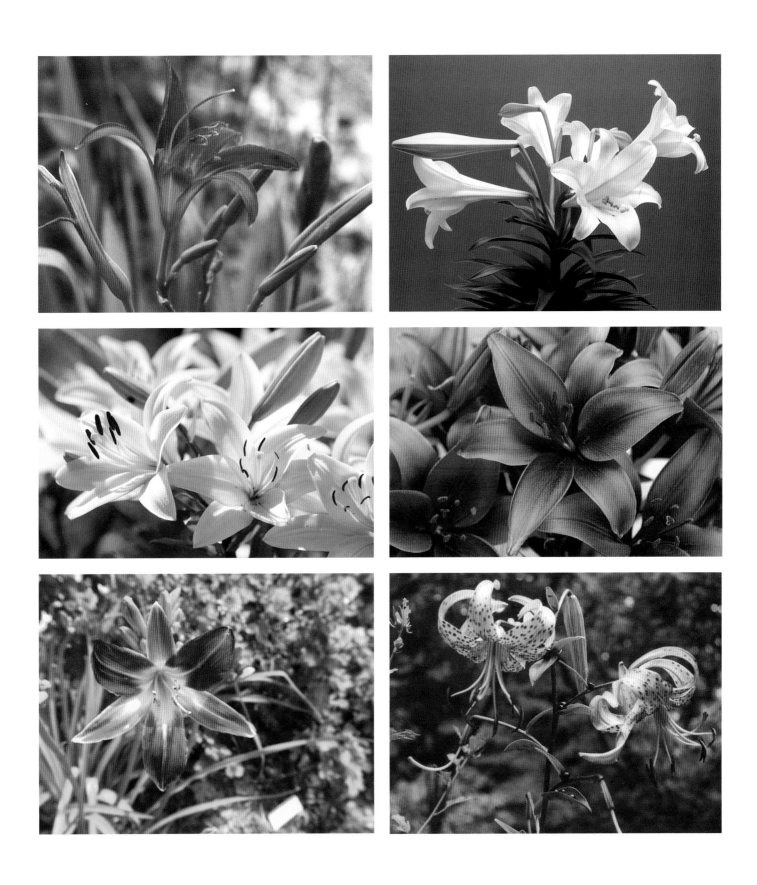

MAGNOLIAS

I absolutely love painting these stately flowers. A family friend gave me two tiny seedlings so I could someday enjoy painting the ones I grew. The surviving one of the pair, after five years, stood only a foot tall. I hope it grows faster than that so I can be around to paint it!

PALETTE
- Hauser Medium Green
- Light Cinnamon
- Hauser Dark Green
- Black Green
- Bittersweet Chocolate
- Celery Green
- Milk Chocolate
- Buttermilk
- Jade Green
- Honey Brown
- Light Buttermilk
- Deep Blush
- Spa Blue
- Blue Mist
- Titanium White
- Yellow Ochre
- Rookwood Red
- Pineapple

BRUSHES
- Flats: Nos. 4, 8, and 12
- Liner: No. 10/0

Hints

1. Use the largest flat brush you can for all steps except for leaf veins, cracks, and flower stamens. Use the liner brush for these.
2. Transfer the pattern for the leaves and edges of the outside flower petals. Undercoat smoothly. Then transfer details for the inner petals and center.
3. Prepare yourself for seeing lots of wonderful colors in something white by studying a group of white shelled eggs. See "Cast Shadows," exercise 3, on page 38.
4. In some cases, thin layers of three colors of washes (blue, yellow, and pink) are stacked one upon the other on the creamy white background of the magnolia. The layering results in some lovely, gentle, almost elusive colors. For best results, work with very little paint, repeating the steps if necessary, to build up the colors slowly.
5. Refer to all colors on the lesson page to match and mix colors.

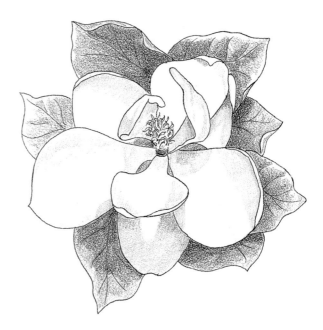

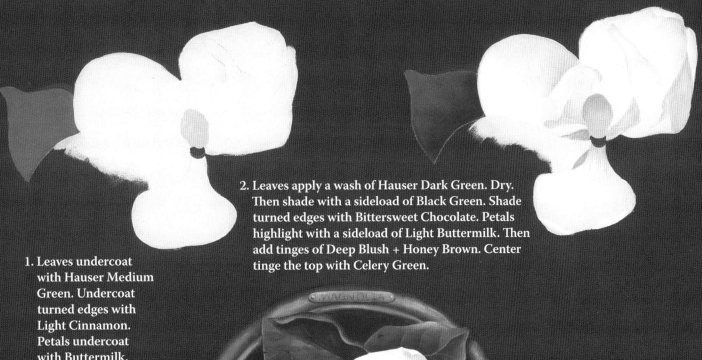

2. Leaves apply a wash of Hauser Dark Green. Dry. Then shade with a sideload of Black Green. Shade turned edges with Bittersweet Chocolate. Petals highlight with a sideload of Light Buttermilk. Then add tinges of Deep Blush + Honey Brown. Center tinge the top with Celery Green.

1. Leaves undercoat with Hauser Medium Green. Undercoat turned edges with Light Cinnamon. Petals undercoat with Buttermilk. Dry. Then transfer lines for inner petals and center. Center undercoat with Yellow Ochre. Undercoat the base with Rookwood Red.

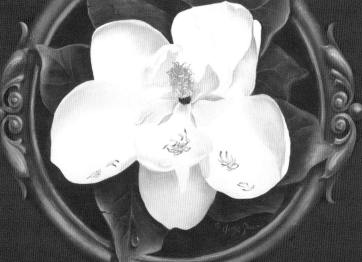

4. Leaves highlight with a sideload of Celery Green. Dry. Then highlight some areas lighter with a sideload of Jade Green. Paint holes and tears (cracks) with Bittersweet Chocolate; highlight them with Honey Brown. Petals merge washes of color and shading into the petals with a thin wash layer of Buttermilk. Then add stronger highlights with Titanium White. Center highlight some stamens with Pineapple; tip some with Rookwood Red.

3. Leaves paint veins thinned Celery Green. Highlight turned edges with Milk Chocolate or Milk Chocolate + Buttermilk. Petals shade with Spa Blue and Blue Mist. Add thin washes of Honey Brown. Center paint stamens Honey Brown.

Final Details
After completing the leaves, the magnolia, and its center, make final adjustments if needed to unify all three elements in shading, highlighting, and color washes by repeating any previous steps.

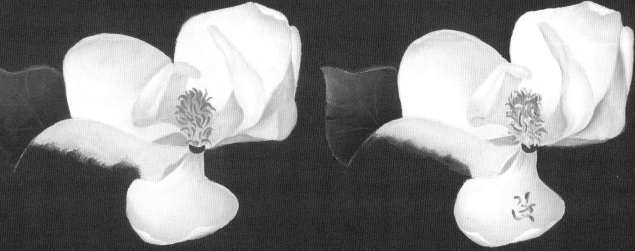

Magnolias Reference Photos

These flowers are unquestionably majestic. And the seed pods are equally gorgeous both with the red seeds and without them. In each case, there's opportunity for adding some lively texture to your painting. The sturdy, glossy leaves reflect light like the gardenia. Be sure to observe the different coloring in the leaves—young versus more mature; tops versus undersides.

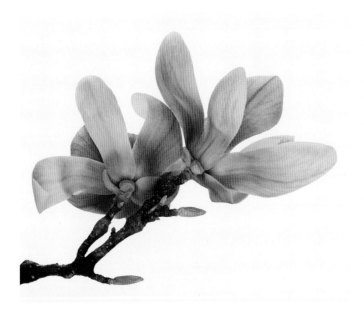
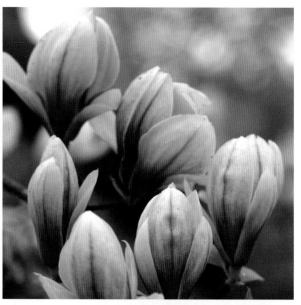

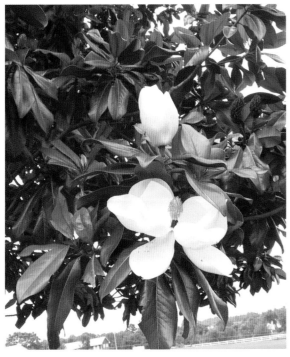

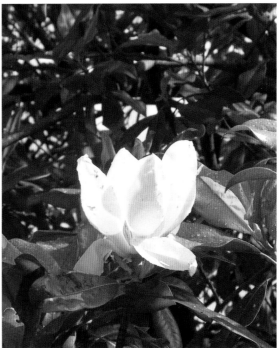

MARIGOLDS

A Welsh weather omen proclaims that marigolds failing to open early in the morning indicates an ensuing storm. I've never tested that omen, but I do know that my tomato plants are happily free of nematodes when marigolds grow around them.

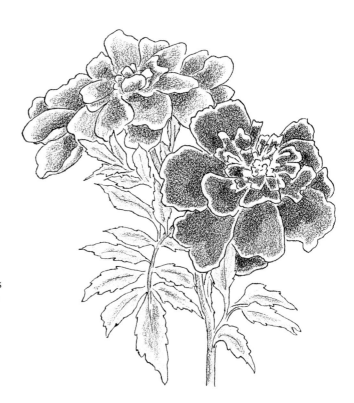

PALETTE
- Marigold
- Georgia Clay
- Napa Red
- Lemon Yellow
- Cadmium Orange
- Primary Yellow
- Celery Green
- Foliage Green
- Jade Green
- Charcoal Grey

BRUSHES
- Flats: Nos. 2, 4, 6, 8, and 10 (or 12)
- Liners: No. 1

Hints

1. Marigolds are quick and easy to paint. Use a selection of flat brushes, always working with the largest brush you can handle for a given area. Use the liner brush to outline the flower petals.
2. Paint the bottom layer of petals first. After that, you may find it easier to paint the remaining layers freehand. See the directions below for painting freehand stroked marigolds. Try both techniques, and perhaps use a combination of the two.
3. Refer to all colors on the lesson page to match and mix colors.

Quick and Easy Marigolds

1. To paint quick, easy brushstroke marigolds, you need to master just one stroke—a dipped crescent stroke. To make the stroke, doubleload the No. 6 flat brush with Marigold on one side, Georgia Clay on the other.
 - Imagine a clock face. Place the dark corner of your brush in the center of the clock, with the light corner facing 10 o'clock.
 - Slide briefly toward 10 o'clock; gradually leaning the brush handle back a little toward you, press down on the dark-paint corner causing the light-paint corner to flare upward. Next, slightly rotate the brush toward 12 o'clock; slightly release the pressure and press again as you continue rotating the brush to point toward 2 o'clock.
 - At 2 o'clock, begin releasing the pressure on the brush, letting the hairs return to the chisel edge. Pull the brush back toward the clock center starting point and lift off.

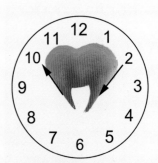

2. To paint the freehand marigold, draw a dime-sized circle around which you will paint the outer layer of petals. Let them dry, then move inward and paint another slightly overlapping row, leaving the dark part of the previous layer showing. Continue making rows, using smaller brushes as needed, until you have no room left. Finish with a few pollen dabs of Marigold.
3. To paint quick leaves, doubleload the No. 4 flat brush with a light and a dark green. Stand the brush on the chisel edge with the light side of the brush facing the outside edge of the leaf. The dark side will shade the center vein area. Zigzag from the base of the leaf to the tip on one side of the leaf, rotating slightly as you paint, leading with the light green, to form a point at the leaf tip. Repeat on the other side.

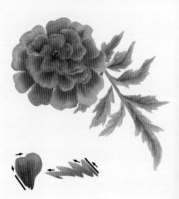

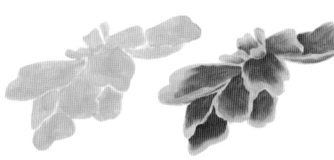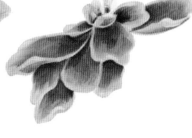

1. Undercoat the petals with Marigold.

2. Doubleload a flat brush with Marigold and Georgia Clay. Place the darker value at the base of each petal.

3. Shade each petal with Napa Red.

4. Highlight the edges of some petals with Lemon Yellow.

1. Brush mix Cadmium Orange + Georgia Clay. Undercoat the petals, leaving the edges unpainted. (Note: Apply basecoat thinly in the flower center.)

2. Shade the petals with Napa Red.

3. Use the liner brush to outline the petals with Primary Yellow.

4. Form the small center petals by painting tight crescent-shaped strokes with a small flat brush sideloaded with Primary Yellow. Highlight the edges with Lemon Yellow.

Leaves

To paint the leaves, randomly dab on thin washes of a variety of greens. I used Celery Green, Foliage Green, Jade Green, and Charcoal Grey + Jade Green for the darkest value. Paint the veins by sliding from the base of the leaf toward the tip on the chisel edge of the flat brush. Keep the leaves understated so they do not compete with the very detailed blossoms.

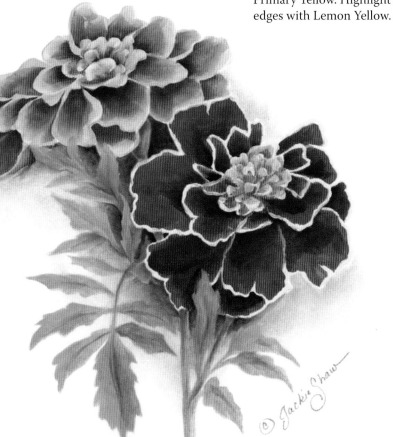

Marigolds Reference Photos

The directions in the lesson are for painting two-toned red and orange marigolds. To paint the yellow marigold, use the palette suggested for painting daffodils.

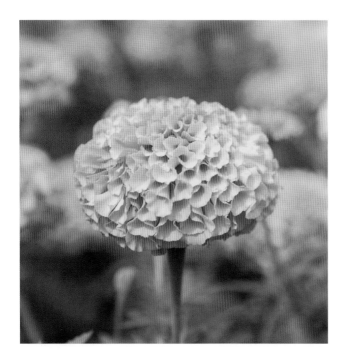

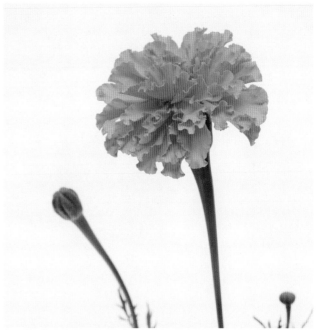

 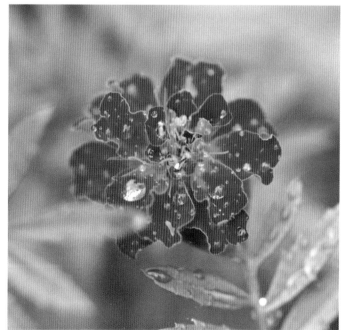

MORNING GLORIES

The first seeds I planted as a child were morning glories. And what an abundance of beautiful, blue flowers those few seeds produced. I was in awe. It's a little more work to paint them than to plant them, but the results are as much fun.

PALETTE
- Light Buttermilk
- Green Mist*
- Primary Yellow
- Marigold
- Black Plum
- Evergreen
- Olive Green
- Teal Green
- Titanium White

*Mix using two parts Arbor Green + one part Sea Glass.

BRUSHES
- Flats: Nos. 6 and 8
- Liner: No. 10/0

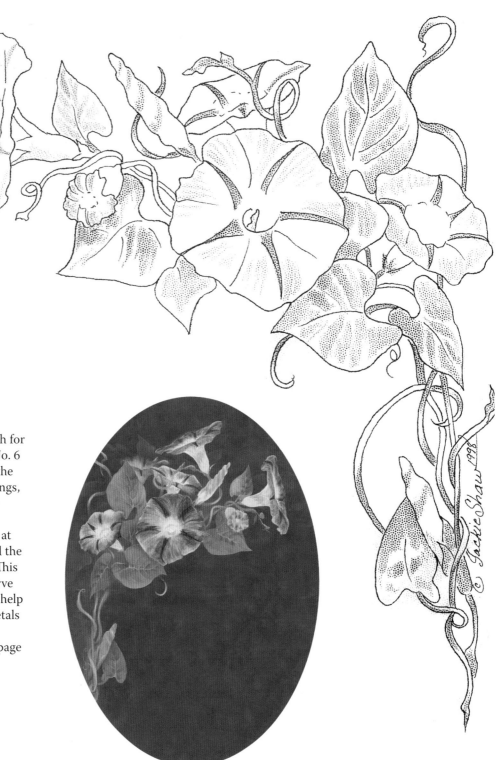

Hints

1. When painting these cheerful blossoms, use the No. 8 flat brush for large leaves and petals and the No. 6 flat brush for smaller areas. For the veins, tendrils, and flower markings, use the liner brush, thinning the paint with water as needed.
2. To paint the flower petals, begin at the outside edge and pull toward the center or down into the throat. This will help you think about the curve and flow of the petal. It will also help establish both the form of the petals and the placement of the veins.
3. Refer to all colors on the lesson page to match and mix colors.

To paint blue morning glories, substitute one or two blues for the Black Plum, then follow the worksheet directions.

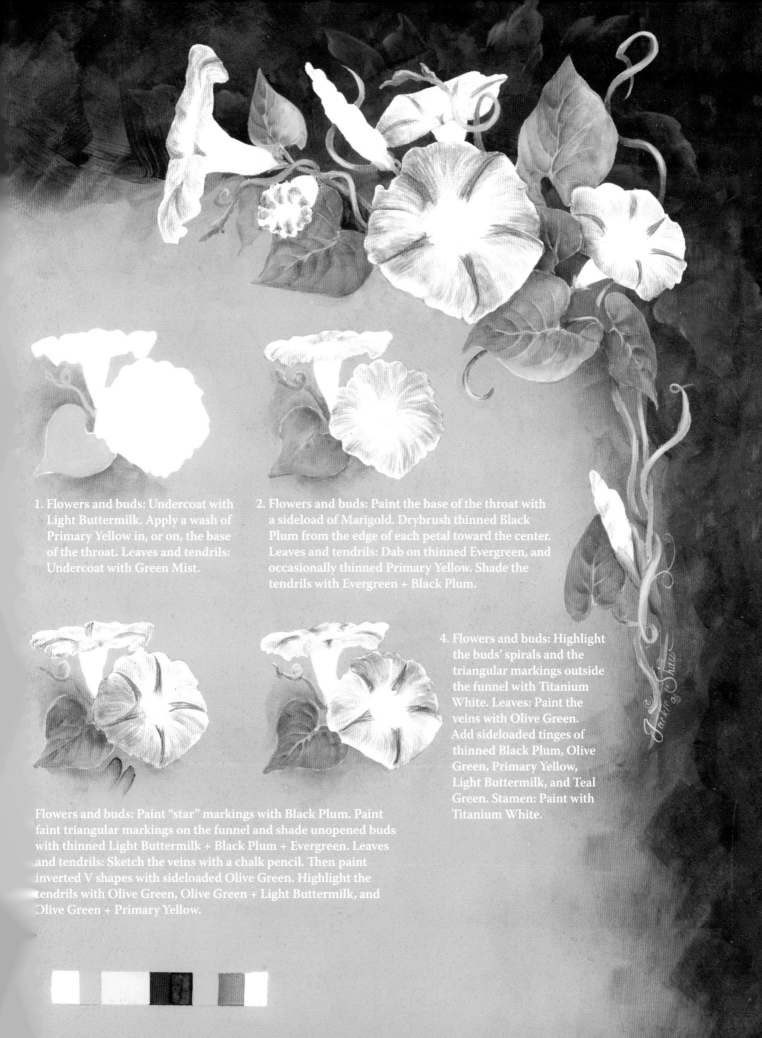

1. Flowers and buds: Undercoat with Light Buttermilk. Apply a wash of Primary Yellow in, or on, the base of the throat. Leaves and tendrils: Undercoat with Green Mist.

2. Flowers and buds: Paint the base of the throat with a sideload of Marigold. Drybrush thinned Black Plum from the edge of each petal toward the center. Leaves and tendrils: Dab on thinned Evergreen, and occasionally thinned Primary Yellow. Shade the tendrils with Evergreen + Black Plum.

4. Flowers and buds: Highlight the buds' spirals and the triangular markings outside the funnel with Titanium White. Leaves: Paint the veins with Olive Green. Add sideloaded tinges of thinned Black Plum, Olive Green, Primary Yellow, Light Buttermilk, and Teal Green. Stamen: Paint with Titanium White.

Flowers and buds: Paint "star" markings with Black Plum. Paint faint triangular markings on the funnel and shade unopened buds with thinned Light Buttermilk + Black Plum + Evergreen. Leaves and tendrils: Sketch the veins with a chalk pencil. Then paint inverted V shapes with sideloaded Olive Green. Highlight the tendrils with Olive Green, Olive Green + Light Buttermilk, and Olive Green + Primary Yellow.

Morning Glories Reference Photos

Look closely at the photos on this page and you'll see some spiraling unopened buds as well as some spent blossoms turning inward on themselves. Often, the density of heart-shaped leaves obscures the abundance of meandering vines, but you can see them clearly on the next page in the photo at top left. Some varieties have very obvious star-shaped rays on the open blossoms.

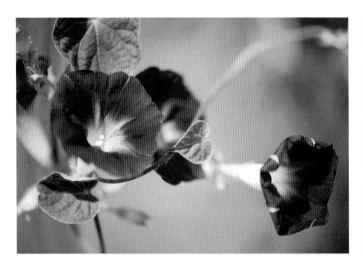
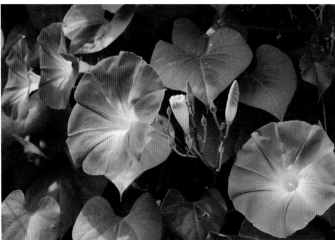

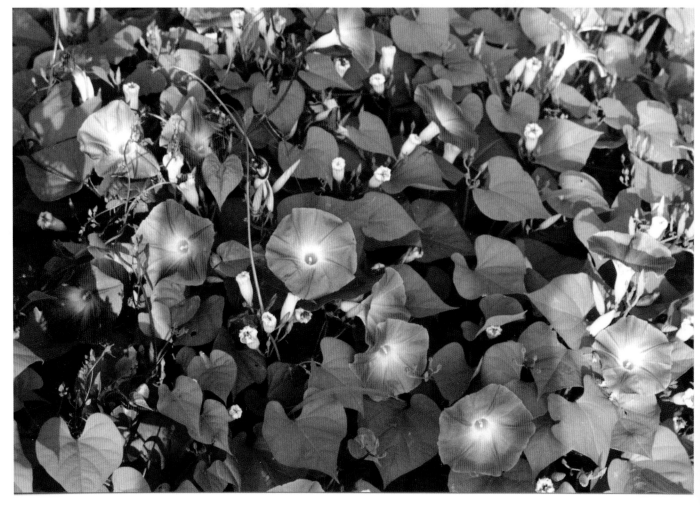

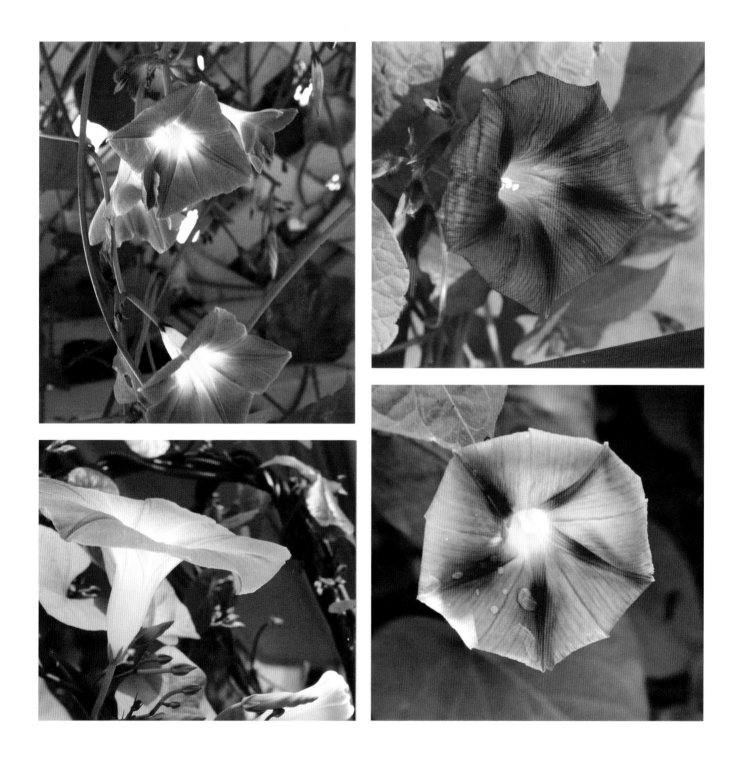

Pansies

For more than 25 years of professional painting, I avoided painting pansies. I even avoided planting them. All because they once grew in the front yard of my beloved grandmother's neighbor. When I was an adoring three-year-old, I picked every pansy my tiny hands could hold and carried them lovingly to my grandmother. To my astonishment and dismay, she sent me back to apologize to the neighbor. I'm sure both of them got over the incident quickly, but it took me 52 years. Now my gardens sport many varieties of pansies, but they always remind me of a hard lesson learned.

PALETTE

· Spice Pink
· Burgundy Wine
· Cranberry Wine
· Naphthol Red
· Cadmium Yellow
· Buttermilk
· Boysenberry Pink
· Black Plum
· Olive Green
· Peacock Teal
· Desert Turquoise

BRUSHES

· Flats: Nos. 4 and 6
· Liners: Nos. 2 and 10/0

Hints

1. Use the flat brushes to apply undercoats, washes, sideloads, and drybrushed highlights. Use the liner brushes to paint veins and fine details.

2. In the lily and morning glory lessons, vein lines in the petals were created by stroking along the contour lines with a flat brush on a watery undercoat. Let's try a different approach with the pansy. This time we'll use a very fine No. 10/0 liner brush and very thin paint, slightly darker than the undercoat. In the lily and the morning glory lessons we painted the vein lines under the overall color. For the pansies, we will place them on top. In both cases, though, it's important that the veins follow the contours. When using the darker color to paint the veins on, rather than under, we must keep them delicate and subtle.

3. Refer to all colors on the lesson page to match and mix colors.

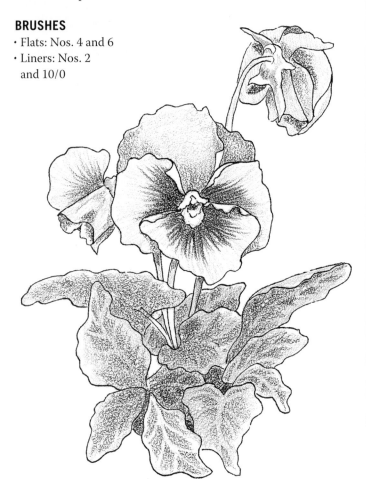

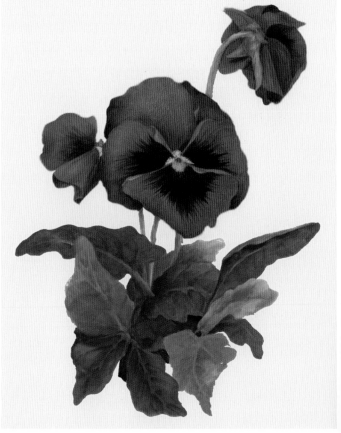

You can use the worksheet directions to paint any single-colored pansy, such as a purple one. Just select related values of the same color—such as a light, medium, dark, and very dark purple, a slightly different purple, and black.

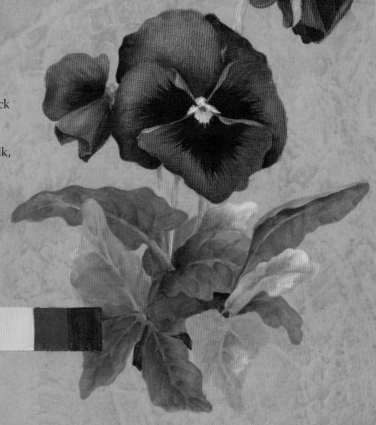

Leaves

1. Undercoat some leaves with Olive Green and others with Desert Turquoise.
2. Sideload a flat brush with Desert Turquoise or Peacock Teal and paint V shapes along the center vein to suggest lateral veins.
3. Add accents with touches of Olive Green + Buttermilk, Peacock Teal + Buttermilk, and Boysenberry Pink.
4. Shade with Peacock Teal + Black Plum.

1. Undercoat pansy petals with Spice Pink. Dab a little Cadmium Yellow in the center, followed by a dab of Olive Green.

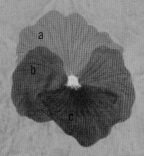

2. (a) Use a liner and thinned Burgundy Wine to paint many fine veins. (b) Apply a wash of Burgundy Wine over the petals. (c) Paint the veins again if necessary.

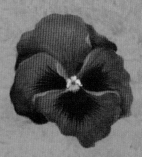

3. (a) Sideload a flat brush with Burgundy Wine and shade the petals. (b) Add a dab of Naphthol Red in the center. (c) Dab Buttermilk in the center at the bases of the side and back petals.

4. (a) Apply scattered tinges of Naphthol Red and Boysenberry Pink on some petals. (b) Then drybrush on highlights of Buttermilk. (c) Paint areas where the petals have flipped over with Spice Pink.

5. Paint the dark shading at the bases of the lower three petals with Black Plum + Cranberry Wine. Paint a wash of Boysenberry Pink lightly over the drybrushed areas. Highlight the petals' turned edges with Spice Pink + Buttermilk.

Pansies Reference Photos

Pansies are cultivated in a wide range of colors and combinations. Use the photographs here as color inspirations.

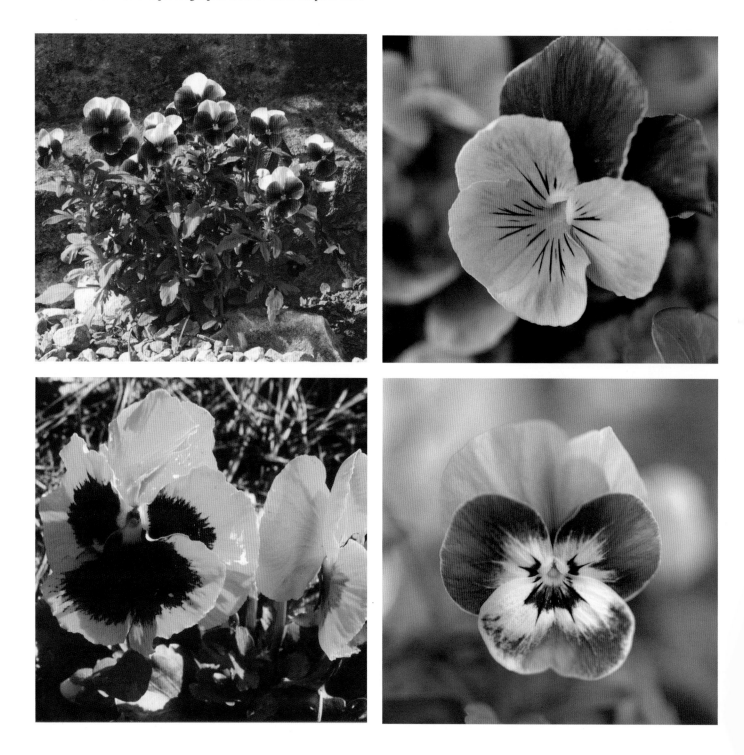

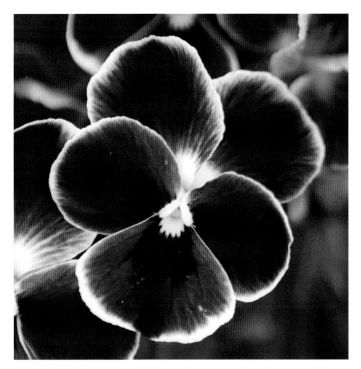

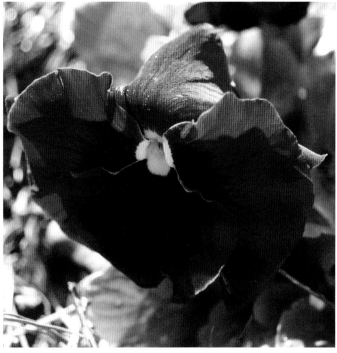

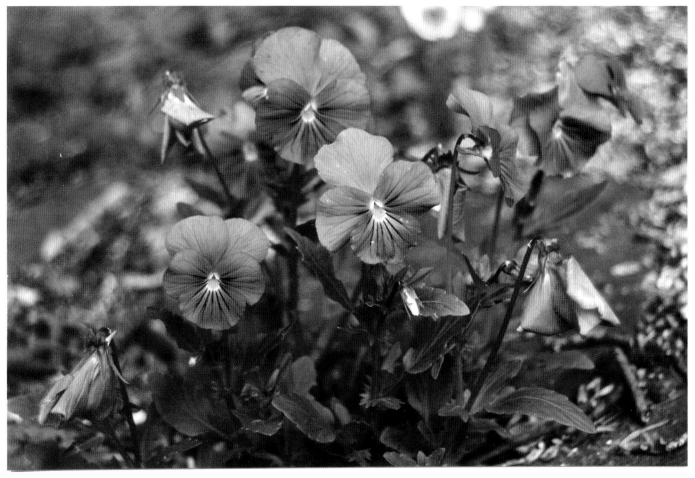

POINSETTIAS

I have a hard time throwing away plants, so the number of poinsettias I had growing (as just green foliage, mind you) was staggering, that is until—through neglect while I was working on this book—most of them died. Only once did I try to get a dozen of them to bloom, carefully monitoring their fourteen hours of darkness each day. I did get four red leaves out of the bunch. Hardly worth the effort!

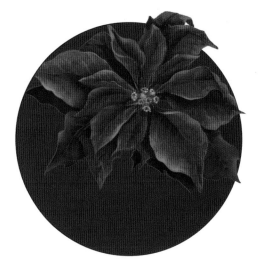

PALETTE

- Peaches 'n Cream
- Antique Rose
- True Red
- Alizarin Crimson
- Red Violet
- Leaf Green
- Peacock Teal
- Black Forest Green
- Hauser Light Green
- Lemon Yellow

BRUSHES

- Flats: Nos. 2, 6, and 8
- Liner: No. 1

Hints

1. Use the No. 8 flat brush for the larger leaves (both red and green), the No. 6 for the smaller ones, and the No. 1 for the tiny center blossoms. Use the liner brush to stipple color on the blossoms.
2. For more information on shading between the lateral veins in the leaves (step 3), see the pansies worksheet (page 102).
3. Refer to all colors on the lesson page to match and mix colors.

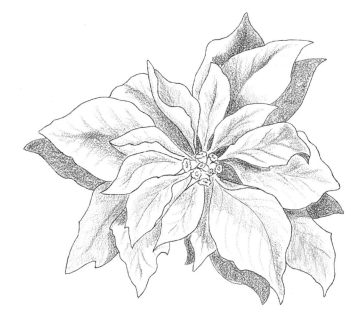

The cream and the red background colors were "safe" choices—sure to work. The blue-green background is an unexpected color choice—sort of makes one perk up and pay attention.

Red Leaves

1. Undercoat the leaves with two or more coats of Peaches 'n Cream.

2. Use a flat brush to apply a puddly wash of Antique Rose. The wash should appear blotchy, not smooth.

3. Sketch the veins using chalk. Sideload a flat brush with True Red and paint V shapes between the lateral veins, fading out toward the petal edges.

4. Sideload a flat brush with Alizarin Crimson and intensify the shading along the center vein.

5. Sideload a flat brush with Red Violet and add shadows and areas of deep shading. Sideload the brush with Peaches 'n Cream and apply highlights.

Green Leaves

Follow the instructions for the red leaves, substituting the following colors: step 1, Leaf Green; step 2, Peacock Teal; step 3, Black Forest Green; step 4, Black Forest Green + Alizarin Crimson; step 5, Hauser Light Green for highlights.

Blossoms

1. Undercoat with Leaf Green + Hauser Light Green.
2. Sideload a flat brush with Peacock Teal and shade the base. Use the liner brush to stipple Lemon Yellow on top.
3. Stipple on True Red in the center of the yellow area.

Accent green leaves with tinges of Antique Rose, True Red, and/or Red Violet.

Poinsettias Reference Photos

Paint white poinsettias using colors from the gardenias palette (page 66). To paint the speckled poinsettias shown on the next page, use a "scruffy" brush to apply red "freckles" over a cream-colored basecoat. (The actual blossoms of the poinsettia are in the center of all those gorgeous red, white, or speckled leaves.)

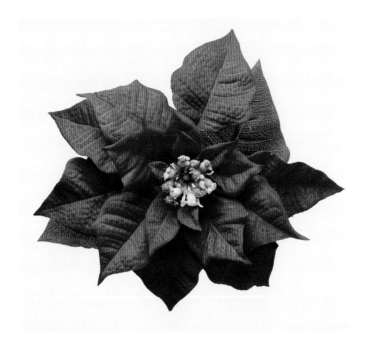

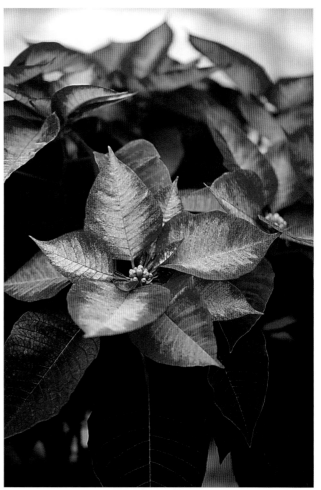

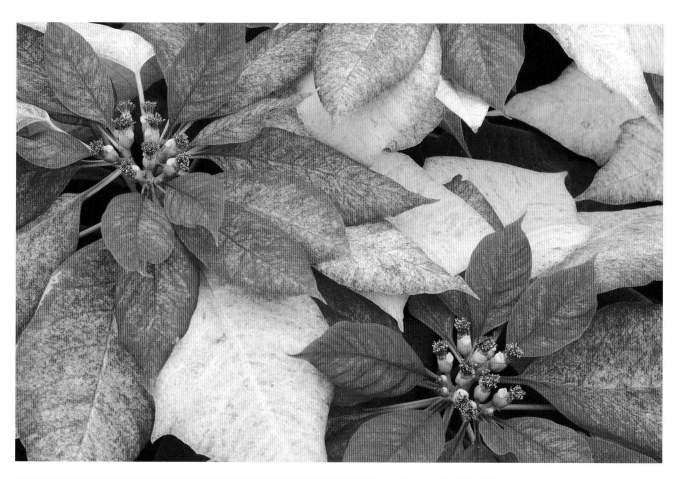

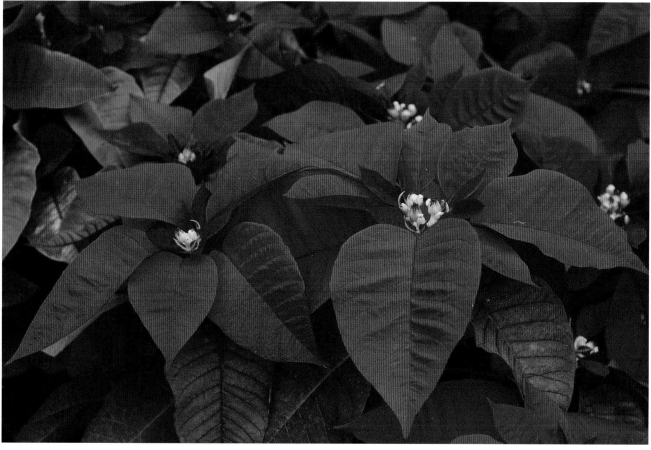

GLOSSARY

A

Accent: A small application of color to add interest, such as a blush of red on a pear, or a tinge of brown on a leaf.

Acetate: A lightweight, plastic-like transparent sheet; useful for testing colors, strokes, and designs before placing them on a project.

Analogous: Describes a color scheme that includes any two to seven adjacent colors on the color wheel (for example: yellow, blue, and green).

B

Background color: The underlying color of a painted piece.

Basecoat: The initial coat(s) of paint applied to an item to prepare it for additional layers of colors and design work; the background color.

Bright: A type of flat brush with short hairs; sometimes called a chisel brush. Also describes color that is clear, brilliant, and intense.

Bristles: The hairs of a brush; more specifically, the stiffer types of hair such as hog or boar bristles.

Brush blending: Mixing two or more colors together by picking up a little of each with a brush, rather than a palette knife, and stroking, not stirring, them together on the palette.

C

Calyx: The group of leaf-like sepals at the stem end of a flower or fruit.

Cast shadow: A shadow caused by an object blocking the flow of light.

Chalk pencil: A pencil with chalk in place of graphite; used in designing. Chalk can be easily removed with a damp cloth.

Chisel edge: The bottom edge of a flat brush.

Complementary colors: Colors that are located diametrically opposite one another on the color wheel (for example, red and green). They neutralize one another when mixed.

Contour lines: Lines that indicate the dimensional form of an object.

Cool colors: Colors that appear to recede or move away from the viewer (greens, blues, violets).

Cured: Pertaining to the state at which paint, after being applied, has thoroughly hardened through the completion of all internal drying and chemical processes.

D

Doubleloading: The process of loading two colors or values of paint onto one brush so that each color retains its identity while at the same time creating a mixture of the two colors in the center of the brush.

Drybrushing: A technique of applying paint using a brush with very little paint.

E

Extender: A type of painting medium, that, when added to acrylic paints, prolongs the drying time.

F

Faux finish: Fake finish; technique of painting something to look like something else (for example, painting wood to resemble marble).

Ferrule: The metal cylinder in which the hairs of a brush are glued and the handle firmly fastened.

Flat brush: A brush having hairs that taper to a flat chisel edge.

Floated color: A thin layer of color that is stroked onto a film of water or painting medium over a dry undercoat color.

Focal area: The center of interest in a painting.

Fully loaded: Describes a brush that is thoroughly filled with a single color of paint.

G

Gradated: Describes an application of paint that progresses from strong to faded color. This effect is usually achieved with a sideloaded brush.

H

Hairs: The bristles of a brush.

Highlight: A representation of the bright reflection of a direct light source.

Hue: Another word for color.

I

Intensity: The pureness or saturation of a color.

Intermediary colors: Colors that lie in between the primary and secondary colors on the color wheel (for example, red-orange, yellow-green, and blue-violet). They are created by mixing a primary color with a neighboring secondary color.

L

Light source: The primary source of illumination of an object; determines position of highlighting and shading.

Liner brush: A brush with a round ferrule housing a small amount of bristles to achieve a fine line when used with paints, inks, and watercolors. The hairs range from short to long.

Local color: The dominant color of an object.

M

Marbleizing: A faux finish technique in which paint is applied to resemble marble.

Medium: A product that is added to paint to prolong the drying time and to render the paint more flexible and easier to work with.

Monochromatic: Describes a color scheme that includes tints and shades of a single hue (for example, light and dark blues).

P

Palette knife: An artist's implement used to mix and apply paint.

Pigment: Material (such as finely ground powder) that adds color to paint.

Primary colors: Red, blue, and yellow; these three colors are necessary for mixing all other colors in the color spectrum.

R

Reflected light: Illumination that is reflected off of an object rather than coming directly from the light source.

Round brush: A brush with hairs formed into a cylinder and tapering to a point.

S

Scumbling: A technique that involves the loose application of color in unconnected strokes to create a broken-color effect.

Secondary colors: Orange, green, and violet; each secondary color is created by mixing together two primary colors.

Sepal: One of a cluster of small leaves comprising the calyx at the base of a flower or fruit.

Shading: A slight variation or difference of color to have a shadowing effect on the area opposite of a light produced area. This is achieved by adding a darker pigmentation or black paint to the main color.

Sideloading: The loading of paint onto only one side or edge of a brush.

Split-complementary: Describes a color scheme that consists of three colors: a main color and the two colors on either side of the main color's complement (for example, yellow, red-violet, and blue-violet).

Sponging: A faux finish technique of applying paint with a sponge to achieve a mottled effect.

Stippling: A method of applying paint to achieve a speckled color effect by repeatedly dabbing with the brush.

Stylized: Describes a design characterized by simplification of form.

Stylus: An implement with a small, rounded point used in transferring designs and to create paint dots. A good substitute is a "dead" ballpoint pen.

T

Taklon: A synthetic filament used as hairs in some brushes.

Temperature: The perceived warmth or coolness of a color. Warm colors advance; cool colors recede.

Tertiary colors: Colors that result from the mixture of two secondary colors. Each tertiary color contains all three primary colors.

Tint: Color that is created by adding a lighter value or white to any color.

Tone: Color that is created by adding black plus white to any color.

Transfer: To copy a pattern either freehand or by use of a specially treated artist's transfer paper.

Transfer paper: A paper coated with chalk, graphite, or other substance that, when placed between the pattern and the object to be decorated, aids in the transferring of the design.

Triadic: Describes a color scheme that includes any three colors equidistant from one another on the color wheel (for example, red, yellow, and blue).

U

Undercoat: The first layer of color used to define the shape and basic color of the subject matter, to be followed by highlighting and shading colors.

V

Value: A color's relation to white or black or the grays in between; the lightness or darkness of a color.

Value scale: A scale that specifies nine distinct steps of gray between black and white; created by Henry Albert Munsell, an early American portrait painter.

W

Warm colors: Colors that appear to advance or move toward the viewer (reds, oranges, yellows).

Wash: A layer of thin paint applied over a dry layer of paint to alter its color slightly.

INDEX

Note: Page numbers in *italics* indicate step-by-step lessons.